IMAGES
of America

TAMPA

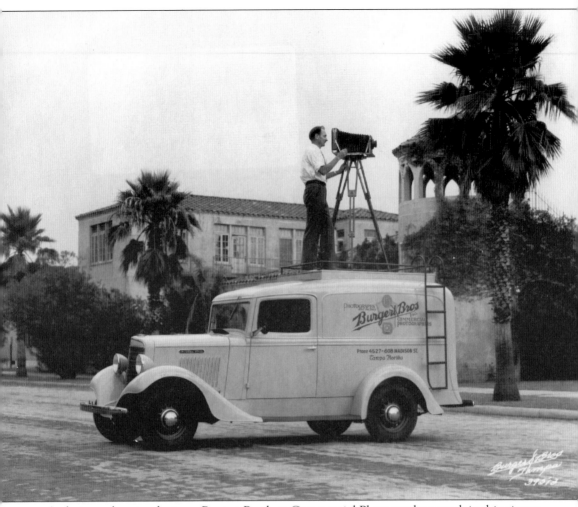

A photographer stands atop a Burgert Brothers Commercial Photographers truck in this picture taken on Davis Island on July 20, 1936. The Burgert Brothers were one of the first businesses established in the Tampa Bay area. (Courtesy of HCPL.)

IMAGES
of America

TAMPA

Robert Norman and Lisa Coleman

ARCADIA

Published by Arcadia Publishing,
an imprint of Tempus Publishing, Inc.
2 Cumberland Street
Charleston, SC 29401

Printed in Great Britain.

Library of Congress Catalog Card Number: 2001088280

For all general information contact Arcadia Publishing at:
Telephone 843-853-2070
Fax 843-853-0044
E-Mail sales@arcadiapublishing.com

For customer service and orders:
Toll-Free 1-888-313-2665

Visit us on the internet at http://www.arcadiapublishing.com

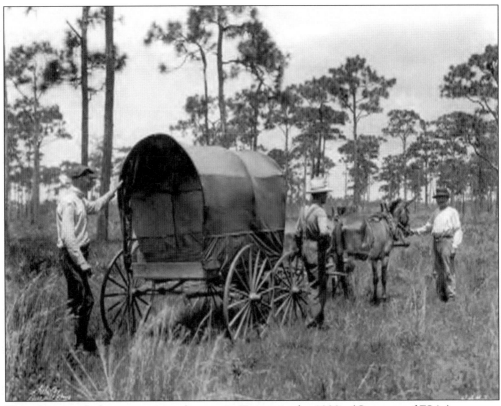

This photograph shows a prairie schooner in Tampa in the 1880s. (Courtesy of FSA.)

CONTENTS

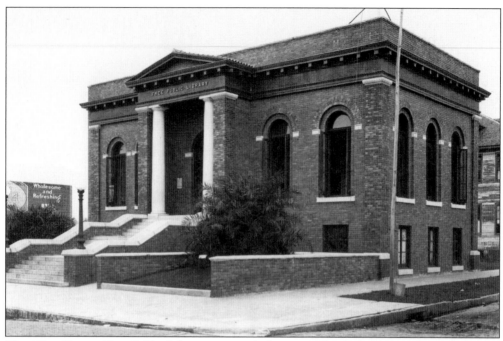

The West Tampa Free Public Library, pictured above on March 6, 1918, is located at 1718 North Howard Avenue. (Courtesy of HCPL.)

ACKNOWLEDGMENTS

The authors would like to thank the Tampa-Hillsborough County Public Library (downtown) for all their help and cooperation during this project. The majority of the photographs in this book came from the Burgert Brother collection located at this facility. In addition, we would like to thank the Tampa Historical Society, Florida.com (state photograph archives), the *Tampa Tribune*, and *La Gaceta* (English-Spanish-Italian paper). The remaining photographs came from public domain. Throughout this book, certain images will be followed by the following photograph credits: Tampa-Hillsborough County Public Library (HCPL) or Florida State Archives (FSA).

INTRODUCTION

Tampa's modern story began in 1823 when Robert J. Hackley, a pioneer from New York City, became the first United States citizen to settle in the area now known as Tampa Bay. A year later, the army built Fort Brooke, which opened a path for white settlers to build their homes. A small village grew around the fort and was named Tampa after that bay that surrounded it. The bay, itself, was actually named for a Native American village that had once existed in the same area. Surviving many setbacks from the time it became a village until the 1880s, Tampa slowly strengthened, but it wasn't until 1881 that Tampa showed signs of becoming a prosperous city in which many industries, such as fishing, cattle, citrus, and cigars would thrive.

Throughout the 1800s, Tampa struggled to become a major city, but while other parts of Florida flourished, Tampa experienced a slower start because of disease, the Seminole and Civil Wars, and political mishaps. Disease, mainly yellow fever, discouraged many people from bringing their families to the community. In 1882, the population of Tampa was just 400, but by 1885, the city's population had grown to almost 3,000. Florida became a territory of the United States in 1921 under the leadership of Andrew Jackson, who was elected the state's first governor.

In 1881, Henry Bradley Plant brought the railroad to Tampa and became one of the icons that would help Tampa develop into what it is today. Before the railroad, it was difficult to get to Tampa. Travelers had to journey by horse or stagecoach to reach the area, and the stagecoach was a two-seated wagon that provided quite a bumpy ride. Resources in Tampa were also limited, and there were not many jobs to entice people to move to the area. By 1882, Plant developed a way to bring steamers and the railroad together to better accommodate travelers from the West Indies and the eastern part of the United States. Tampa began to flourish when the cigar industry prospered, and soon many cigar factories were opened in response to the "supply and demand" economy.

In 1904, the Tampa tradition of the Gasparilla festivities and the Florida State Fair began. The first Gasparilla invasion brought the pirates in by horseback. The first time they arrived by ship was in 1911, and that tradition is carried through today in the popular festival.

Between 1900 and the 1920s, Tampa grew at an amazing rate. But just as it affected the entire country, the Great Depression, which began in 1929, sent the Tampa Bay area into its own downward spiral. Temporary camps were set up all around the area to provide food and shelter for those who were left with nothing; however, during the early 1920s, prominent businessmen continued to open new stores and factories.

Tampa began its rebuilding process, and in the 1930s, the automobile replaced streetcars. The population in Tampa reached 100,000 by 1930. To offset the Depression that followed the "crash," Florida legalized gambling at horse and dog tracks in 1931. In 1933, slot machines were added to that revenue. In 1935, the Work Projects Administration (WPA) approved construction for a municipal airport on Davis Island at a cost of $105,343. By 1939, the WPA had over 8,000 workers employed.

In the 1940s, new stores were built in Tampa and an urban renewal was underway. World War II played a large role in this period of economic revitalization. MacDill Air Force became home to over 25,000 military personnel, and the Tampa economy boomed with the huge amount of soldiers spending money in the local community. In addition, the federal government spent $1.5 billion in Florida between 1941 and 1945. The Tampa shipyards gained a great deal from that spending spree and remain important to the region's economy today.

Tampa was officially incorporated in 1955, bringing freeway construction, business expansion, and growth to the area, but the enormous number of people coming to Florida was almost overwhelming. In May 1954, Al Austin, a modern-day pioneer, saw a great opportunity when his father encouraged him to open a construction company. In September of that same year, Austin's company began building homes on Davis Island. In 1958, Austin decided to purchase property on what is now West Kennedy Boulevard in the Westshore section of Tampa, where he built a small office building for his thriving company and leased part of the space to a major oil firm.

Tampa has suffered through many growing pains through the decades, but it continues to expand with new developers, new dreamers, and new money. There is no doubt that Tampa Bay is here to stay.

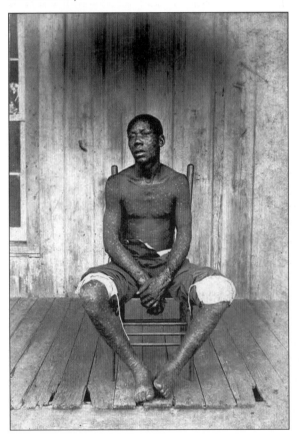

A smallpox case is seen here at the pest house in Tampa, c. 1900. Dr. Leslie W. Weedon, a health officer, took his son Frederick R. to observe the disease in this case. Frederick R. Weedon later became a doctor as well. (Courtesy of FSA.)

One

1880s

*H*enry Bradley Plant, a Connecticut businessman, started the railroad boom in 1881 by obtaining a charter for a South Florida railroad from Sanford, Florida on the St. Johns River to Tampa Bay. By 1885, railroad tracks passed through Hillsborough County, new businesses opened in the small community of Tampa, and the H.B. Plant Hotel was completed. The railroad also opened other doors to Tampa Bay. Citrus and vegetable growers from South Florida now had a way to deliver their goods in less time. Plant's railroad also attracted the Key West cigar industry, as well as many other investors who started trolley lines and electric companies in the growing region.

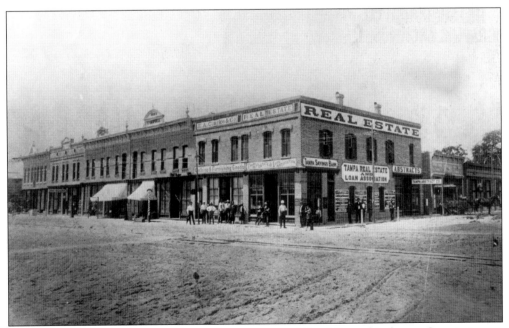

Tibbett's Corner, which sits on the southwest corner of Franklin and Lafayette Streets, is seen here, c. 1889. (Courtesy of HCPL.)

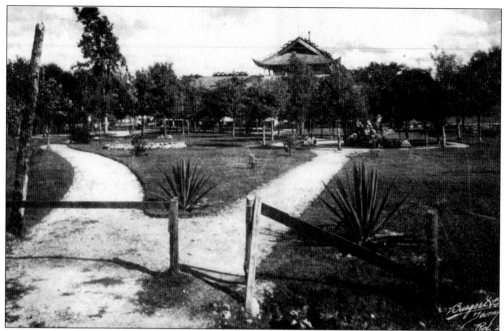

Ballast Point Park sidewalks, landscaping, and a partial view of a pavilion appear in the background of this c.1884 photograph. (Courtesy of HCPL.)

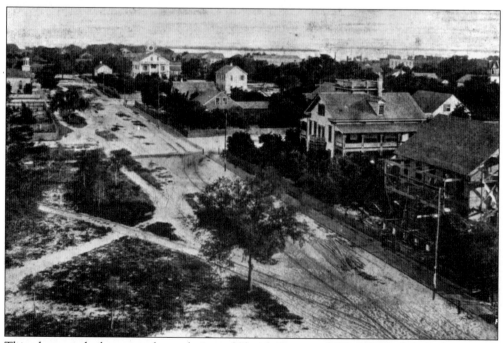

This photograph shows an elevated view of Florida Avenue (400–700 blocks), looking south from the roof of a building on Polk Street, c. 1884. (Courtesy of HCPL.)

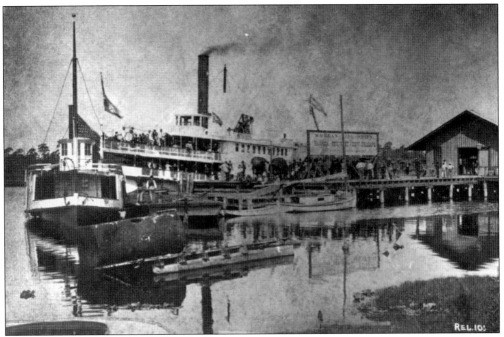

Here, the Morgan Line paddlewheel steamers share the dock with the vessel *Erie*. The population in Tampa was just 600 souls at the time this *c.* 1885 image was captured. (Courtesy of HCPL.)

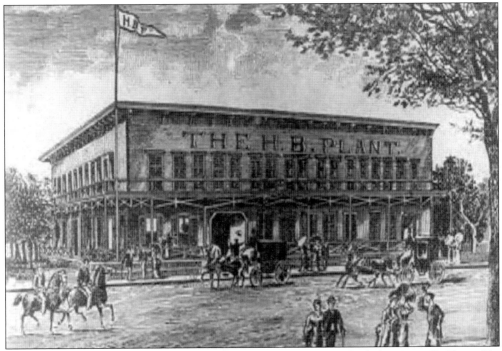

This is an 1883 pen sketch of the H.B. Plant Hotel, which was built by Henry B. Plant. His vision helped to turn Tampa into a thriving city. The hotel was completed in 1884. (Courtesy of HCPL.)

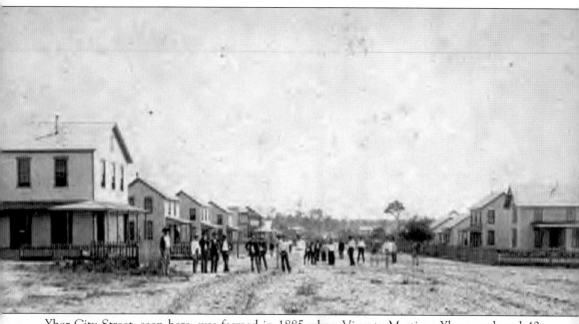

Ybor City Street, seen here, was formed in 1885 when Vicente Martinez Ybor purchased 40 acres of land located northeast of Tampa. Plant's railroad enticed Ybor to import Cuban cigar makers to the Tampa area. Shortly afterwards, Spanish cigar manufacturers and German box makers flooded into Ybor City, which became the first multiethnic manufacturing port to establish labor organizations and ethnic clubs. The streets of Ybor City may have looked like a town from "out west," but it wasn't long before the dirt roadways were paved with red brick. (Courtesy of HCPL.)

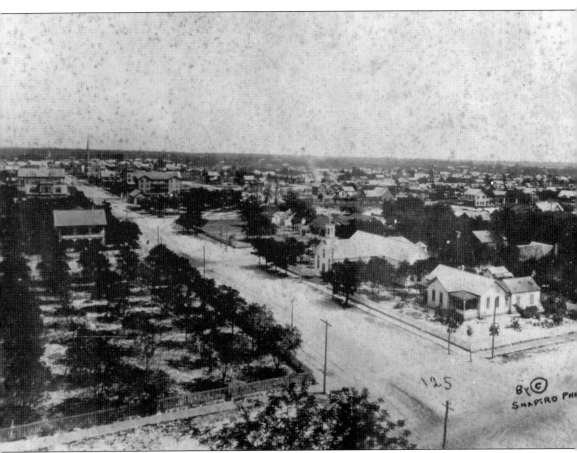

This photograph shows the view looking north on Florida Avenue from the top of the courthouse, c. 1886. As can be seen, Tampa, the seat of Hillsborough County, is starting to become a substantial residential community. New homes were built as more families moved to the area. Orange groves, like the one pictured in a lot on the left, helped to provide Tampa with economic stability. (Courtesy of HCPL.)

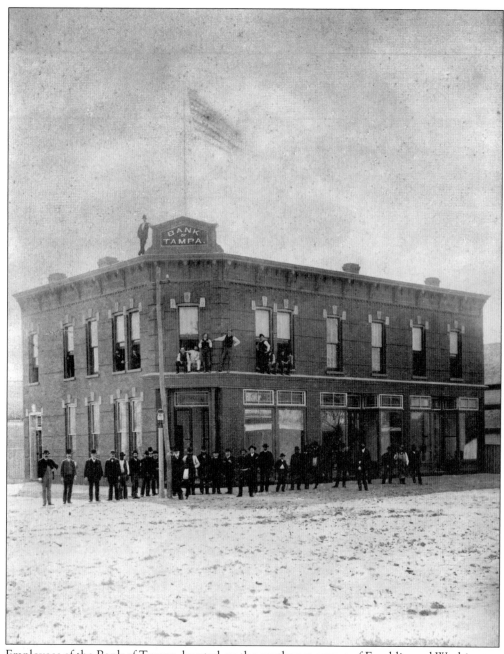

Employees of the Bank of Tampa, located on the southwest corner of Franklin and Washington Streets, stand in front of the building for this *c.* 1886 photograph. (Courtesy of HCPL.)

Two

1890s

During the winter of 1894, Tampa recorded a low temperature of 18 degrees, and in February 1895, snowfall came to Tampa for the first time in recorded history. In 1898, the Spanish-American War brought Theodore Roosevelt and his Rough Riders to Tampa, where they set up camp prior to launching an attack against Cuba and Puerto Rico. Because Ybor City had become home to so many Hispanic immigrants, this war hit close to home for many residents. Volunteers numbering 23,000 supported Roosevelt and his campaign during the invasion, and the soldiers added to the improving economy while they ate in the local restaurants and frequented the social clubs that Tampa and Ybor City offered.

In this c. 1898 photograph, transport ships at Port Tampa wait to carry troops to Cuba during the Spanish-American War. (Courtesy of HCPL.)

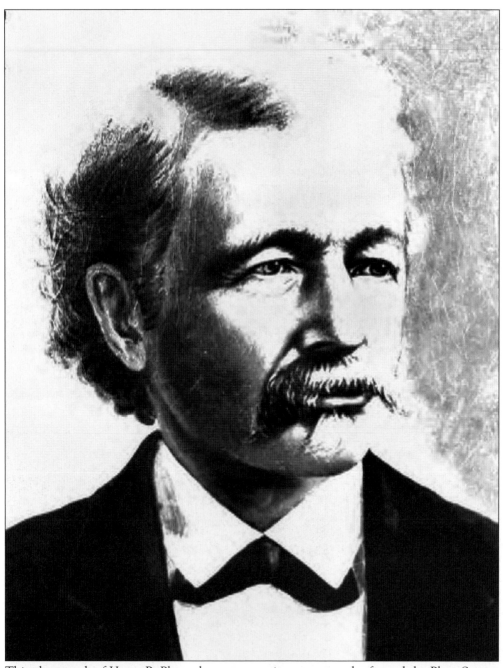

This photograph of Henry B. Plant, the transportation magnate who formed the Plant System of railroads, steamships, and a hotel, was taken in 1899. (Courtesy of HCPL.)

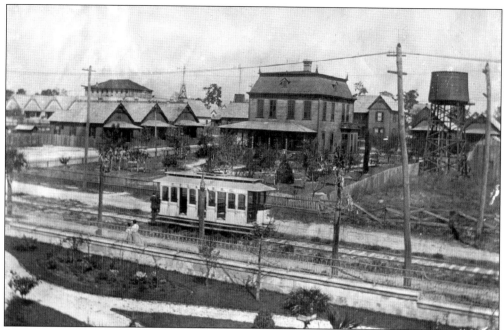

A streetcar is seen here in front of Jose Arango's home at Twelfth Avenue and Twentieth Street in Ybor City, c. 1898. (Courtesy of HCPL.)

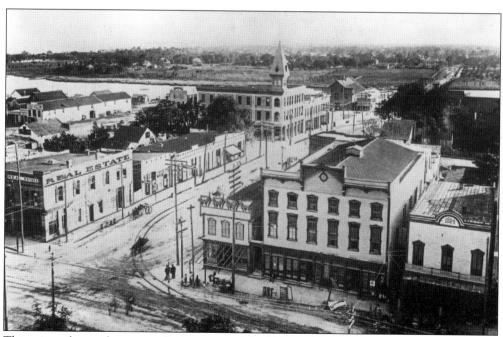

This view shows downtown businesses and buildings along Lafayette Street west to the Hillsborough River, c. 1892. (Courtesy of HCPL.)

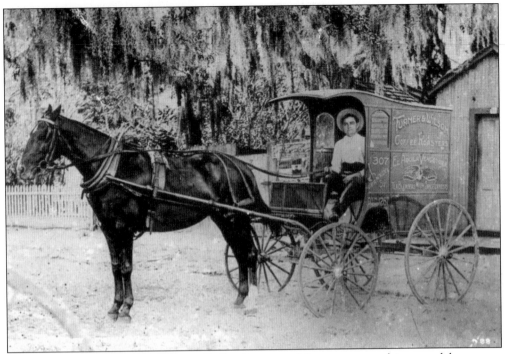

This image of a Turner & Wilson Coffee Roasters delivery wagon, driver, and horse was captured *c.* 1895. (Courtesy of HCPL.)

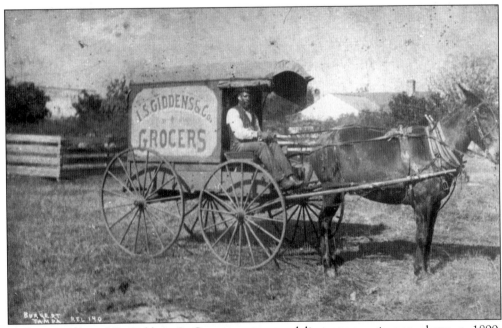

A driver with an I.S. Giddens & Company grocery delivery wagon is seen above, *c.* 1899. (Courtesy of HCPL.)

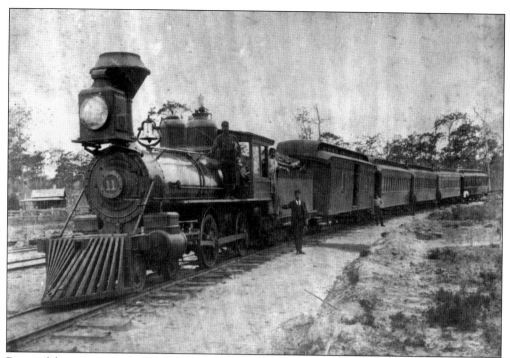

Pictured here is a Sanford & St. Petersburg locomotive train with workers standing by the passenger cars, c. 1893. (Courtesy of HCPL.)

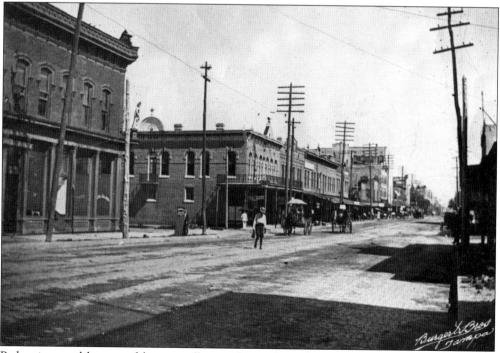

Pedestrians and horse-and-buggy traffic pass by in this view of Franklin Street looking north from Washington Street, c. 1989. (Courtesy of HCPL.)

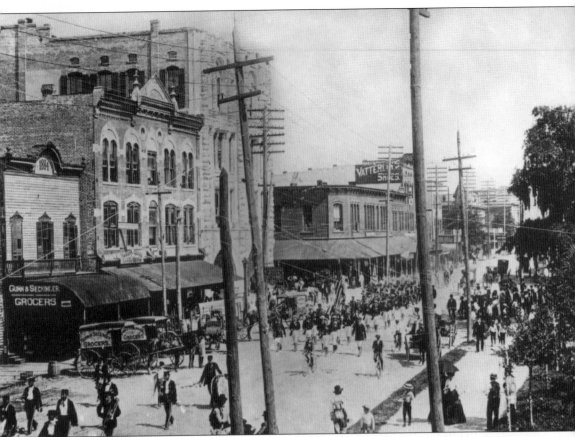

In this c. 1897 scene, Franklin Street is full with a parade of soldiers, a band, and spectators as many celebrated America's involvement in the Spanish-American War. Between the strength of the U.S. Navy and the fighting spirit of ground troops like those seen in this picture, the Spaniards were forced to surrender on August 14, 1898. Tampa was forever changed because it housed and supported troops prior to their departure to Cuba. (Courtesy of HCPL.)

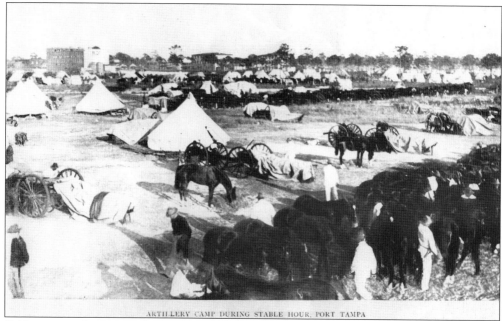

ARTILLERY CAMP DURING STABLE HOUR, PORT TAMPA

Soldiers waited impatiently for supplies and transportation, and some of these individuals decided to organize and outfit their own regiments. Teddy Roosevelt was one of those men when he created the Rough Riders. Regardless of the chaos of getting started, the teams that were organized were strong, and they quickly defeated the Spanish with minimal casualties. Above is an artillery camp at Port Tampa City during the Spanish-American War, c. 1898. (Courtesy of HCPL.)

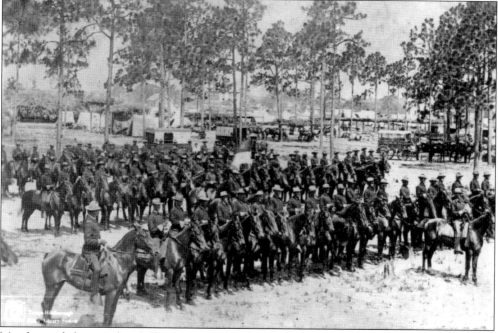

Members of the cavalry drill on grounds near the Port Tampa City army camp, c. 1898. (Courtesy of HCPL.)

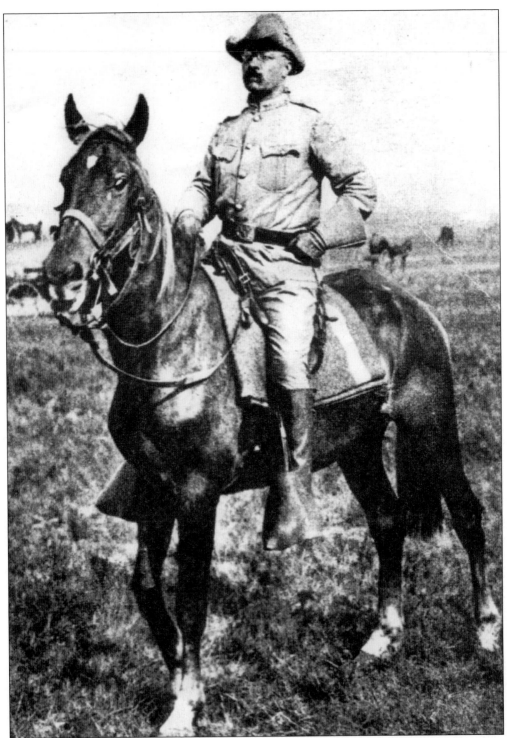

Col. Theodore Roosevelt of the Rough Riders rides on horseback in Port Tampa City, c. 1898. Roosevelt resigned his commission as assistant secretary of the Navy rather than miss out on his chance at glory. (Courtesy of HCPL.)

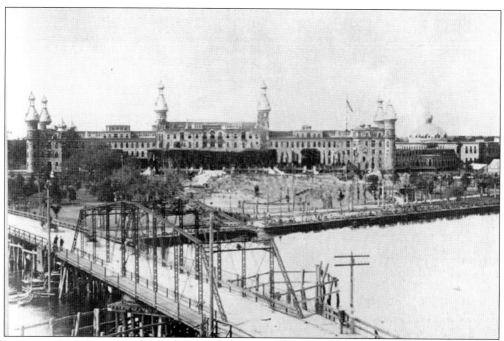

Pictured here in 1890 is the Lafayette Bridge with the Tampa Bay Hotel visible in the background. (Courtesy of HCPL.)

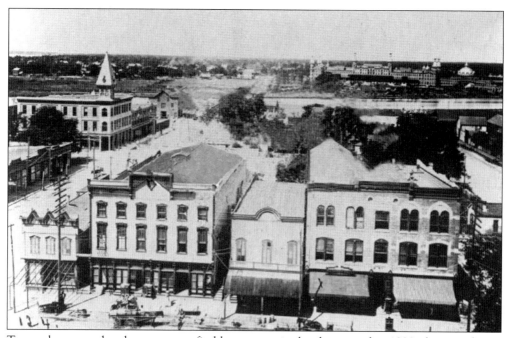

Tampa has started to become a profitable community by the time this 1890 photograph was taken. The view, looking west toward the Tampa Bay Hotel, includes the 100–200 blocks of Lafayette Street and the 400 block of Franklin Street. (Courtesy of HCPL.)

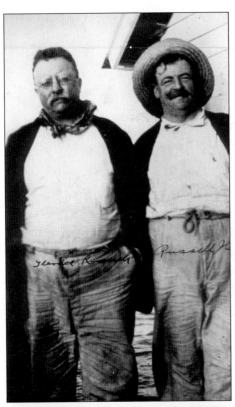

Theodore Roosevelt is pictured here with his spear fishing guide Russell J. Colio, *c.* 1898. (Courtesy of HCPL.)

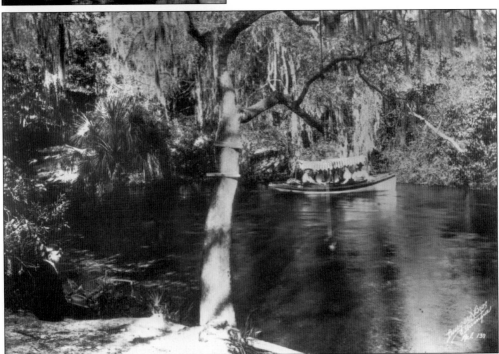

In this photograph, boaters glide along the Hillsborough River near Sulpher Springs, *c.* 1899. (Courtesy of HCPL.)

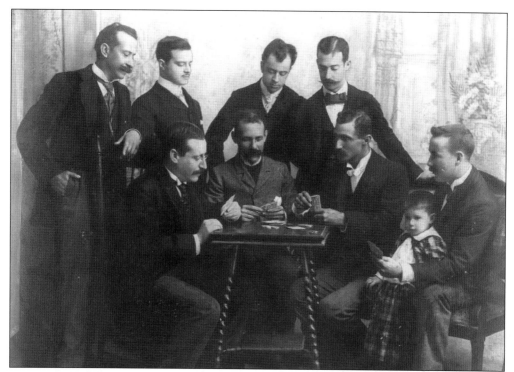

Cigar manufacturers try their luck at playing a game of cards at the Cherokee Club in this c. 1895 photograph. (Courtesy of HCPL.)

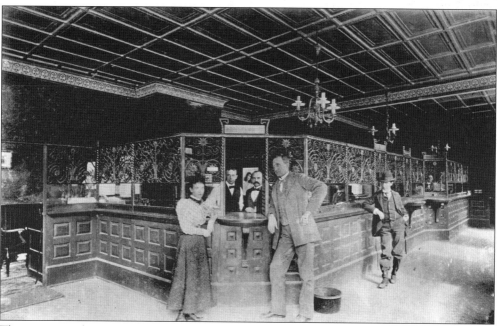

This c. 1894 photograph shows an interior view at the Exchange National Bank with of customers and tellers present. (Courtesy of HCPL.)

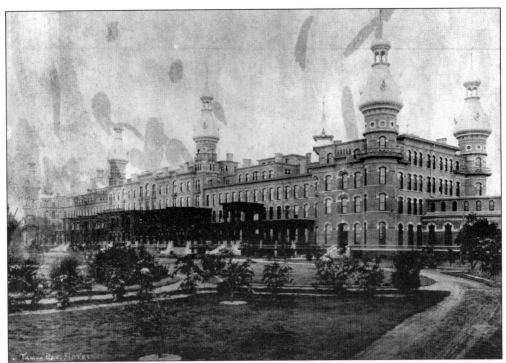

The newly completed Tampa Bay Hotel and the surrounding grounds are seen here in all their splendor, *c.* 1891. This hotel became the new home of the University of Tampa in 1933 and was renamed Plant Hall. (Courtesy of HCPL.)

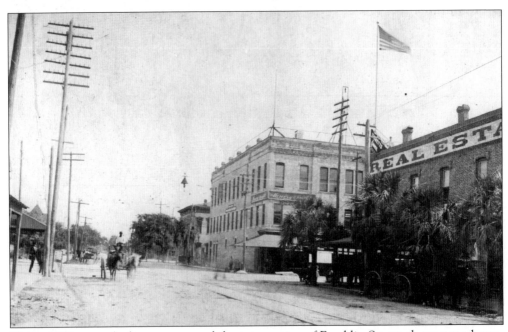

This *c.* 1898 scene, looking east toward the intersection of Franklin Street, shows some horse-and-wagon traffic on Lafayette Street. (Courtesy of HCPL.)

Three

1900s

*T*he Gasparilla Festival and Florida State Fair began in 1904 and became a yearly tradition in
Tampa. The two events were held together until 1977, when the Florida State Fair moved to its
present location on Highway 301. Gasparilla is a celebration much like Mardi Gras, and for almost
100 years, pirates have invaded and taken over Tampa Bay in honor of the mythical legendary pirate
Jose Gaspar. Festivities begin when the world's only fully rigged pirate ship sails into the heart of Tampa
Bay. Hundreds of pleasure boats flank the 165-foot ship that is made entirely of steel and is topped by
three masts. Gasparilla continues with parades and parties during the month of February.

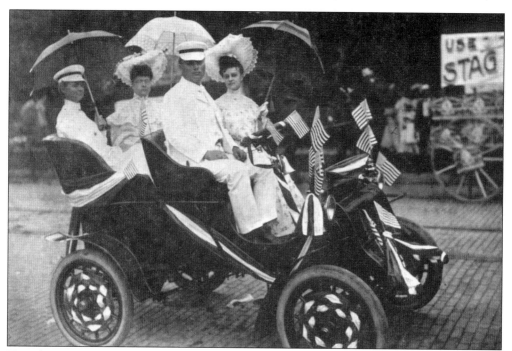

Two elegant couples in a decorated 1903 Cadillac participate in the first Gasparilla parade held
on May 4, 1904. (Courtesy of HCPL.)

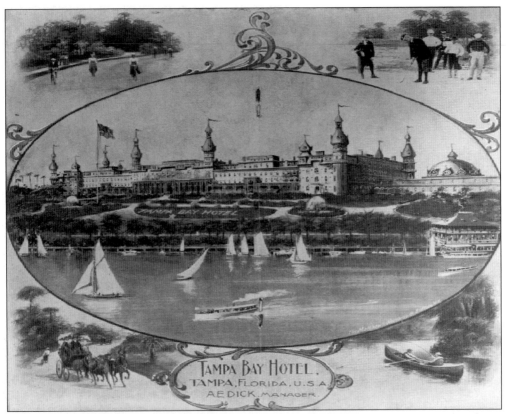

The Tampa Bay Hotel advertisement seen here was copied from a c. 1902 hotel brochure. (Courtesy of HCPL.)

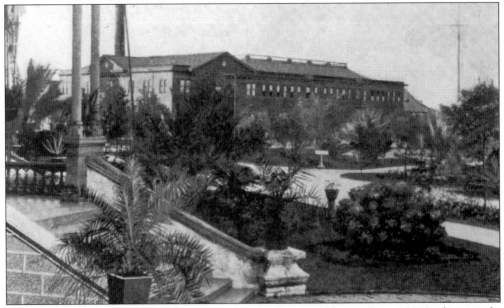

The casino and grounds of the Tampa Bay Hotel are visible in this c. 1902 photograph. (Courtesy of HCPL.)

Elsie Hart, a telephone operator at the Peninsular Telephone Company switchboard, works at her station, c. 1904. (Courtesy of HCPL.)

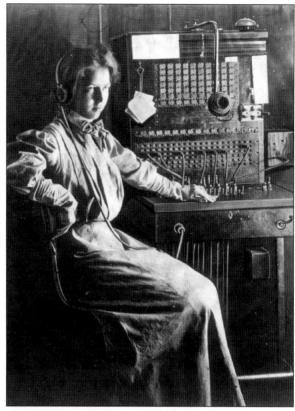

"Elmer Webb," a La France horse-drawn steam piston pumper, was assigned to station No. 4 of the Tampa Fire Department. It is seen above, c. 1905. (Courtesy of HCPL.)

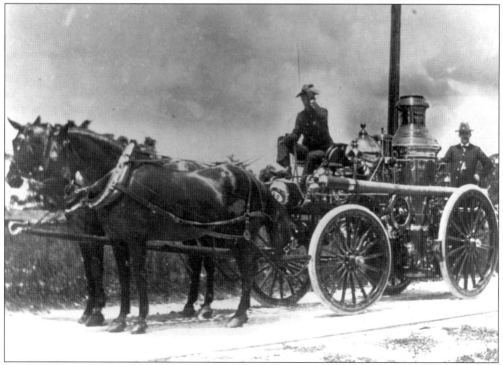

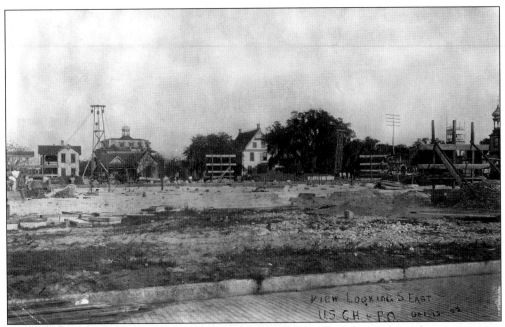

This December 15, 1902 photograph provides a view of the cleared site where the construction of the Federal Building has just begun. (Courtesy of HCPL.)

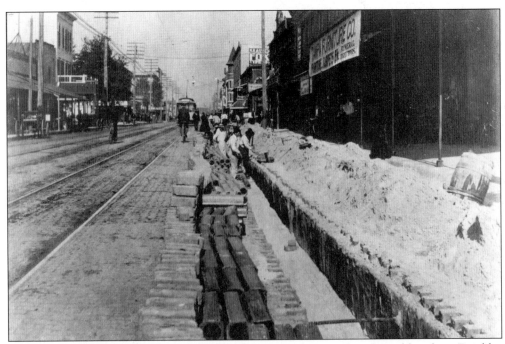

In this view looking north, Peninsular Telephone Company workers lay cables along Franklin Street, *c.* 1901. (Courtesy of HCPL.)

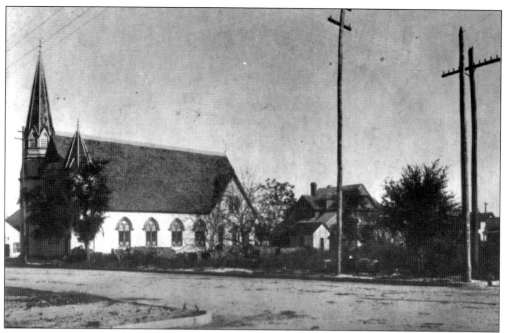

This view shows the southern facade of First Presbyterian Church near Florida Avenue and Zack Street, c. 1900. (Courtesy of HCPL.)

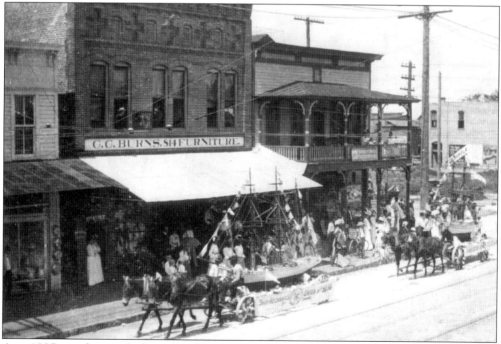

A c. 1905 parade travels down Franklin Street in front of C.C. Burns and Burgert Brothers Commercial Photographers. The horse-drawn float belonged to Ship Mechanics Union No. 9234. (Courtesy of HCPL.)

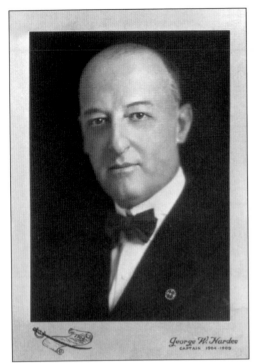

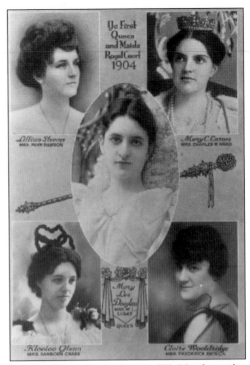

The 1904 photograph, above left, shows the first Gasparilla captain, George W. Hardee, who served from 1904 to 1905. The first Gasparilla queen, Mary Lee Douglas, and her maids, Lillian Stevens, Mary C. Carnes, Klooloo Glenn, and Claire Woolbridge, are pictured in the 1904 photograph above right. (Both courtesy of HCPL.)

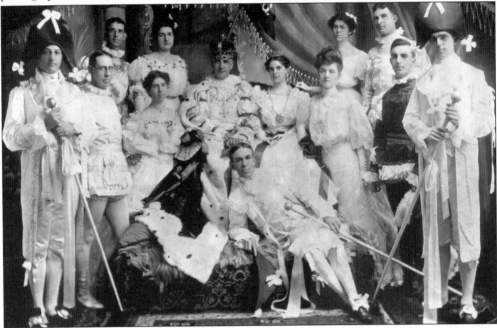

This photograph shows the Gasparilla II Royal Court of 1905 with King William C. Gaither, Queen Mary Carnes, and Captain George W. Hardee (on the far left.) (Courtesy of HCPL.)

32

Four

1910s

*T*he first flight in Tampa occurred on February 19, 1911, when a crowd of 12,000 people attended the "Aero Race" held in West Tampa. The pilots were arrested after the show and charged with violating a Florida law that forbade Sunday exhibitions in which there was an admission charge. Tony Jannus flew the first commercial flight—150 feet above the water—from St. Petersburg to Tampa on January 1, 1914. The passenger in the photograph below purchased his ticket at an auction for $400, and the proceeds were donated to the City of St. Petersburg to purchase harbor lights. The St. Petersburg-Tampa Airboat Line operated for just over four months with two round-trip flights daily. The fare for scheduled flights was $5 each way and non-scheduled flights were $10–$20 each way. The Airboat Line broke even during its short existence.

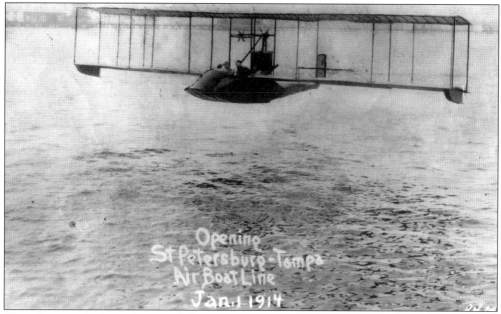

This photograph shows the first flight of Tony Jannus across Tampa Bay. His January 1, 1914 flight from St. Petersburg to Tampa was the first commercial flight in the world. (Courtesy of HCPL.)

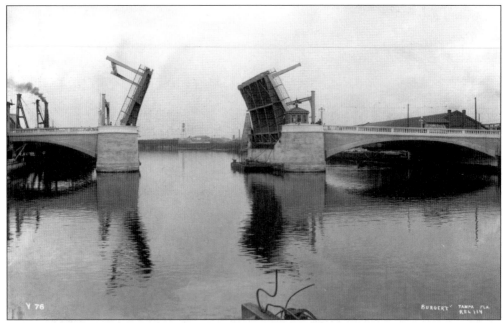

This photograph provides a south side view of the open drawbridge on the Lafayette Street Bridge over the Hillsborough River, c. 1914. (Courtesy of HCPL.)

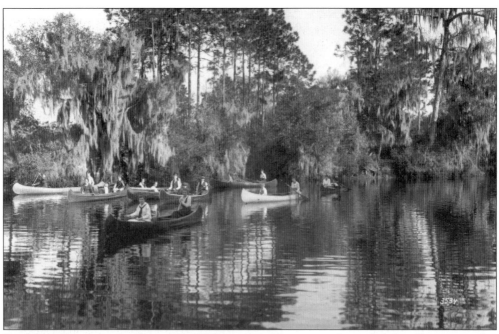

Boaters enjoy a canoe ride on the Hillsborough River just above Sulphur Springs in this December 27, 1917 photograph. The Hillsborough River was known as a "spooner's paradise" because it was such a romantic spot to take a date. (Courtesy of HCPL.)

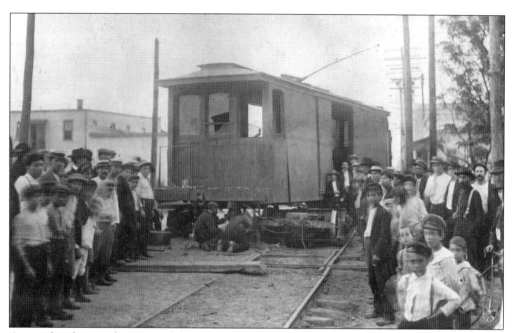

A crowd gathers at the scene of this *c.* 1914 streetcar accident at 3500 Tampa Street. Streetcars like this one became a major mode of transportation carrying folks between downtown Tampa, Ybor City, and Ballast Point. When an accident occurred, it was "big news" for curious onlookers. (Courtesy of HCPL.)

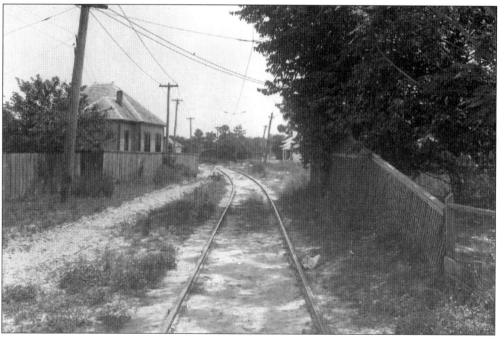

These streetcar tracks, pictured in this *c.* 1914 view looking south, are located at the intersection of Tampa Street and Woodlawn Avenue. (Courtesy of HCPL.)

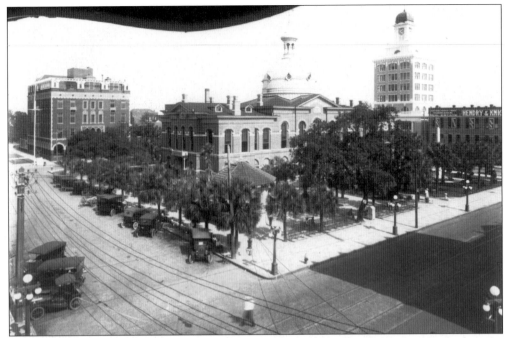

The Hillsborough County Courthouse, seen here on September 16, 1915, is located at the intersection of Madison Street and Franklin Street. (Courtesy of HCPL.)

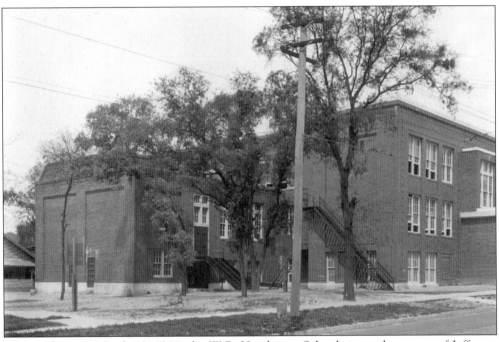

Pictured here on March 10, 1914, the W.B. Henderson School sits at the corner of Jefferson Street and Henderson Avenue. (Courtesy of HCPL.)

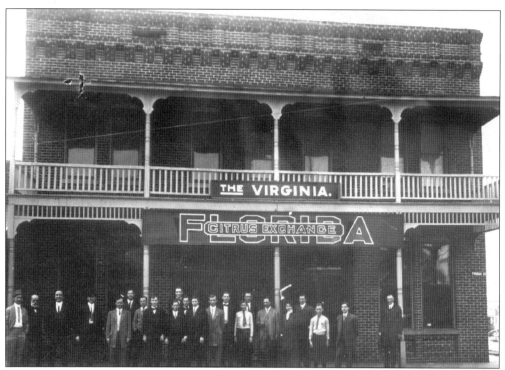

A group of men in suits and ties poses for a *c.* 1910 picture outside of the Florida Citrus Exchange Building at 201 Twiggs Street. A sign for the Virginia is visible on the second-floor balcony railing. (Courtesy of HCPL.)

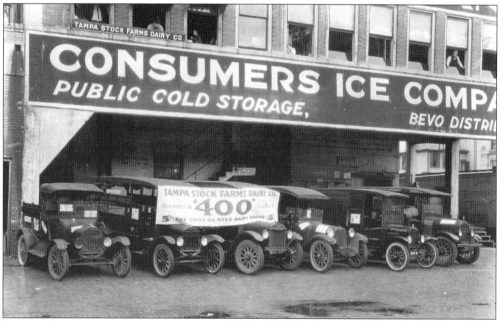

Trucks belonging to the Tampa Stock Farms Dairy Company are parked behind Consumers Ice Company, which was located at the corner of Marion Street and Polk Street. This photograph was taken on May 17, 1919. (Courtesy of HCPL.)

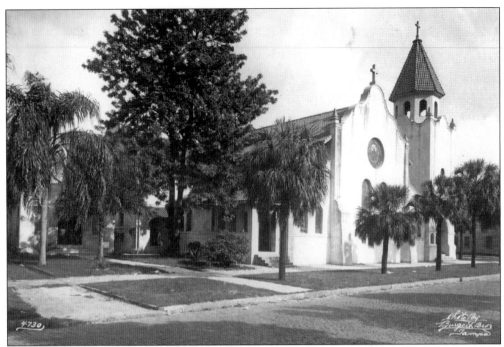

This photograph, taken on October 18, 1919, shows the facade and bell tower of St. Andrew's Episcopal Church at 505 Marion Street. (Courtesy of HCPL.)

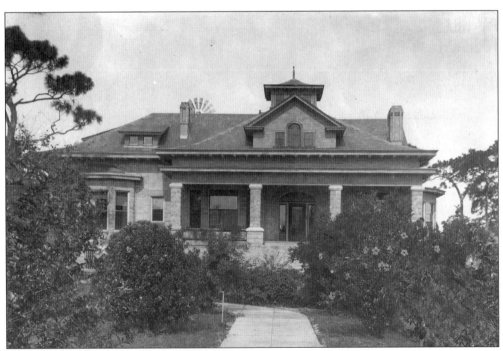

Bayside Hospital, which was located at 4800 Bayshore Boulevard, south of Maryland Avenue, is seen here, c. 1919. (Courtesy of HCPL.)

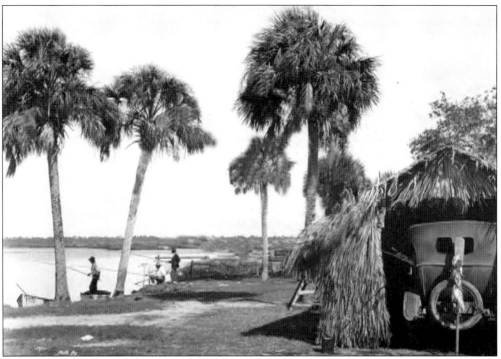

A car is parked under a thatched garage and people fish in Double Branch Bay in this November 2, 1919 photograph. (Courtesy of HCPL.)

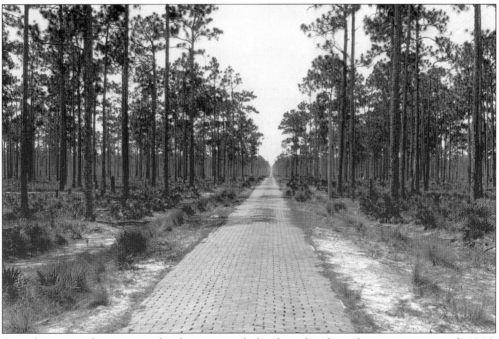

Seen here are the pinewoods along a rural, brick-surfaced road sometime around 1916. (Courtesy of HCPL.)

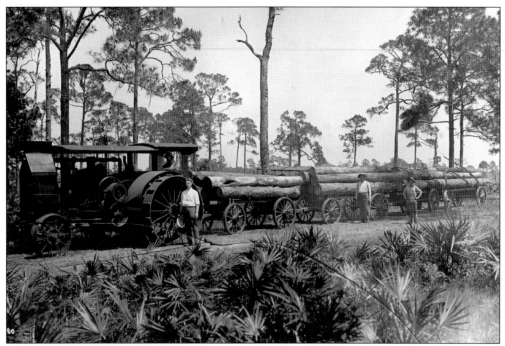

In this *c.* 1916 photograph, a tractor pulls a log train for Reold's Farm Company in Oldsmar (now a suburb of Tampa). (Courtesy of HCPL.)

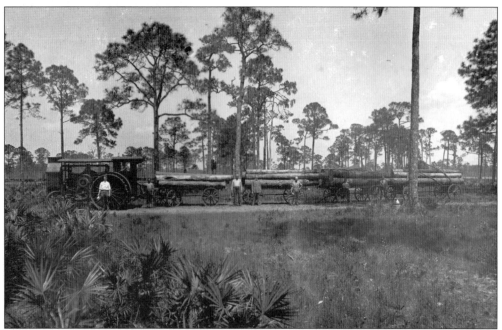

A Reold's Farm Company tractor hauls a train of logs on March 10, 1916. (Courtesy of HCPL.)

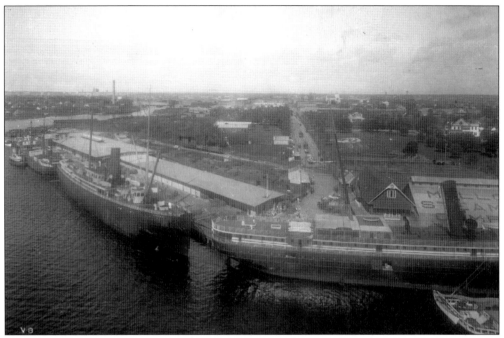

Ships are moored at the Mallory Steamship Company docks at the Hendry & Knight Terminal in the c. 1911 photograph above. (Courtesy of HCPL.)

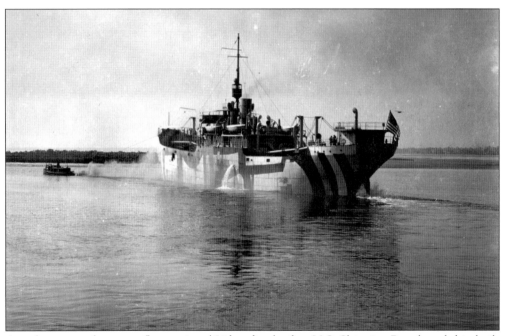

A tugboat tows the camouflage-painted *Lithopolis*, the first U.S. Shipping Board steel ship built in Tampa, on December 6, 1918. (Courtesy of HCPL.)

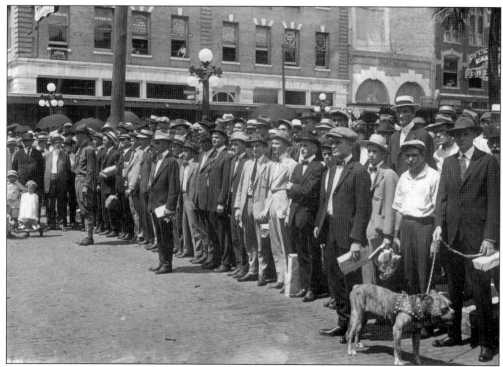

This photograph, taken on September 19, 1917, shows World War I draftees from District No. 1 at Lafayette Street and Franklin Street. (Courtesy of HCPL.)

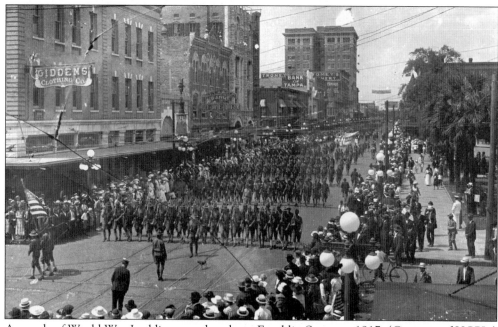

A parade of World War I soldiers marches down Franklin Street, *c.* 1917. (Courtesy of HCPL.)

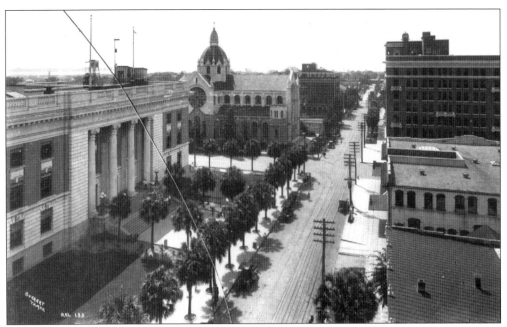

This view of Florida Avenue looking south shows the Federal Building and Sacred Heart Catholic Church on September 16, 1915. (Courtesy of HCPL.)

The Italian Club on the southwest corner of Seventh Avenue and Eighteenth Street in Ybor City is seen here on April 5, 1919. (Courtesy of HCPL.)

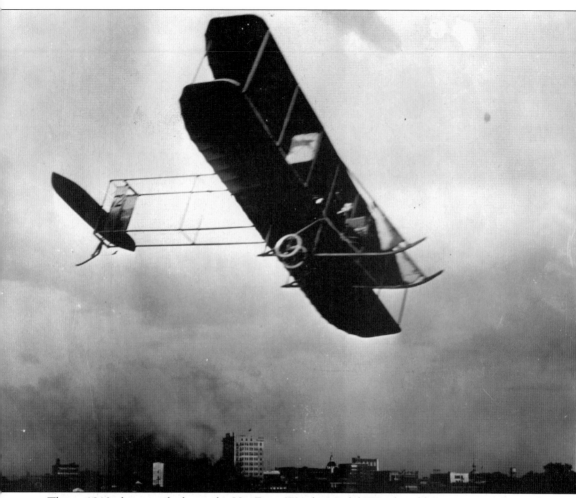

This *c.* 1913 photograph shows the *Vin Fiz*, a Wright Model EX piloted by pioneer aviator Cal Rodgers, who had already made a name for himself across the country when this picture was taken. It all began when William Randolph Hearst, the well-known press magnate, offered a $50,000 prize to the first pilot who could fly across America within 30 days. Rodgers did not win that prize after starting his flight from Sheepshead Bay on Long Island, New York on September 17, 1911, but he proved he wasn't a quitter. It took him 84 days to make it across the states, and 50,000 people showed up to cheer for him as he landed in Long Beach, California. By the time he made this flight above Tampa, Rodgers and the *Vin Fiz* had earned the respect of the world. (Courtesy of HCPL.)

Tennis champion Vincent Richards posed for this photograph at a Davis Island promotional event, *c.* 1919. (Courtesy of HCPL.)

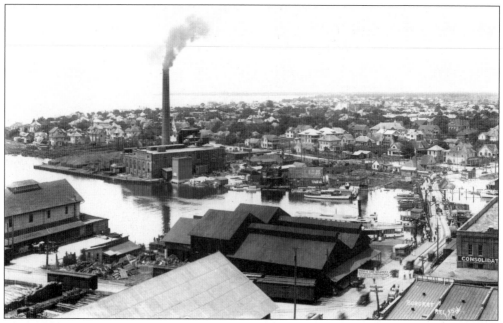

This view of the city looking southwest from Bayview Hotel shows the Jackson Street Bridge and the Tampa Electric Company power plant, c. 1913. (Courtesy of HCPL.)

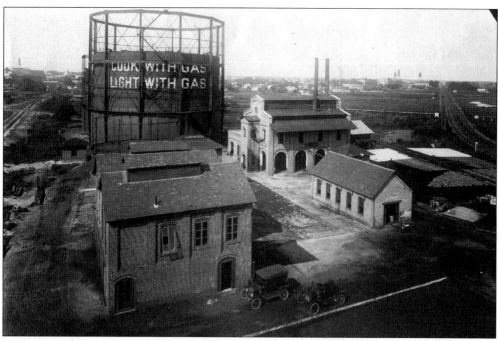

The Tampa Gas Company plant, seen here on July 1, 1915, was located on Twelfth Street between First and Second Avenue in Ybor City. (Courtesy of HCPL.)

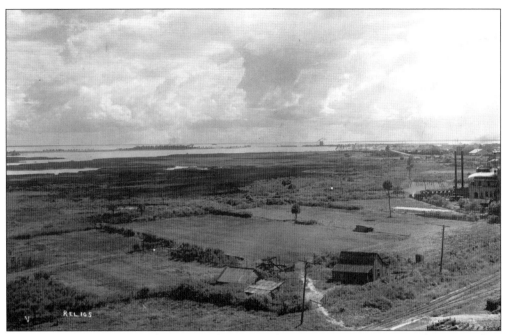

Looking south from Fourth Street, this view shows an estuary zone with surrounding development, *c.* 1911. (Courtesy of HCPL.)

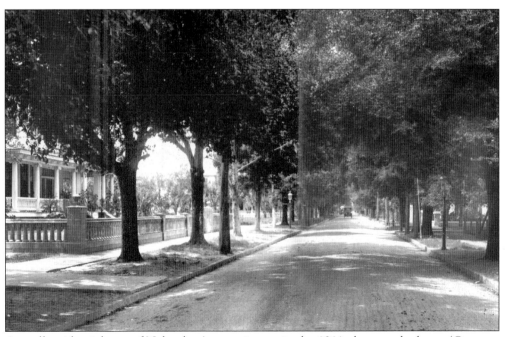

A small residential area of Nebraska Avenue is seen in the 1911 photograph above. (Courtesy of HCPL.)

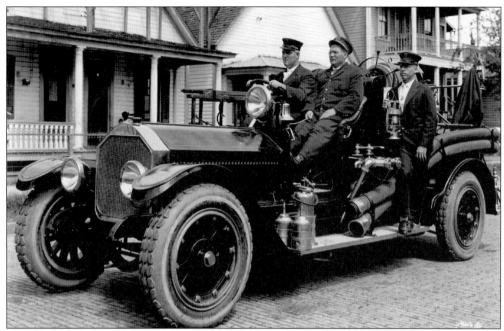

This October 3, 1919 photograph depicts firemen seated in a Tampa Fire Department pumper truck. (Courtesy of HCPL.)

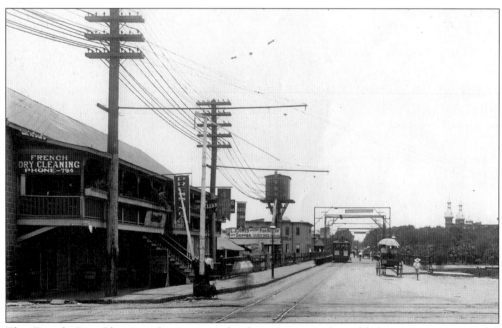

The French Dry Cleaning Company and other commercial establishments appear in this c. 1911 scene looking west on Lafayette Street and Water Street. (Courtesy of HCPL.)

Five

1920s

The Roaring Twenties certainly did not pass by the Tampa Bay region. During that heady age, businesses thrived and people became very wealthy in a very short period of time—that is until 1929, when many lost everything during the ensuing Great Depression. Tampa survived that dark period and recovered more quickly than many cities throughout America. This chapter illustrates how America was changing and how Tampa grew from the horse-and-buggy era to the age of the automobile.

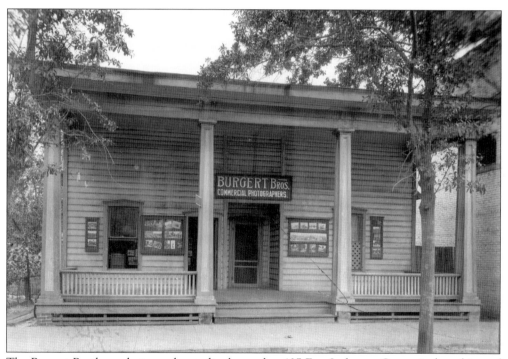

The Burgert Brothers photography studio, located at 407 East Lafayette Street, is the subject of this July 20, 1922 photograph. The display cases along the storefront feature samples of the brothers' work. (Courtesy of HCPL.)

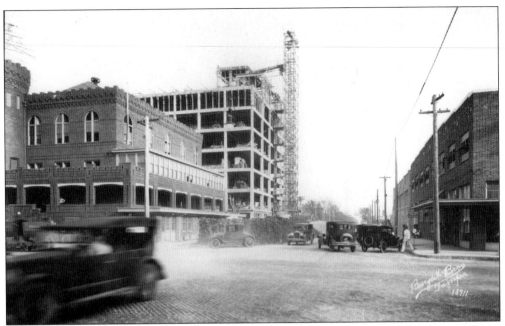

The Tampa Board of Trade Building at 601 Lafayette Street and Morgan Street, along with the adjacent building construction, appear here on April 14, 1926. (Courtesy of HCPL.)

This February 11, 1924 photograph shows the two-story, wooden building of the Nordac Cigar Factory Number Two; the building's street address is unknown. (Courtesy of HCPL.)

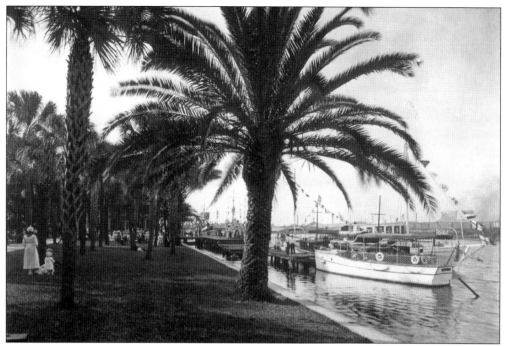

Yachts are moored at the docks next to Plant Park in this *c.* 1920 image. Plant Park borders the Hillsborough River, and the park's entrance is the site of a fountain dedicated to Henry B. Plant for his contributions to the city. (Courtesy of HCPL.)

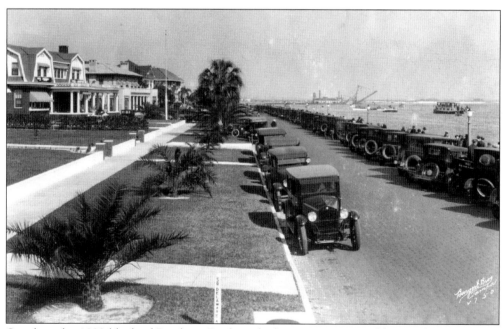

Cars line the 1000 block of Bayshore Boulevard where spectators could view the Tampa Bay Regatta Speedboat Races on February 19, 1925. (Courtesy of HCPL.)

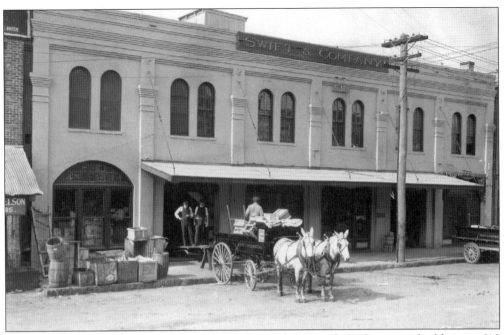

A horse-drawn delivery wagon is parked in front of the Swift & Company building at 610 North Ashley Street in November 1920. (Courtesy of HCPL.)

The Weidman-Fisher Company box factory, pictured here c. 1920, was located at 1102 Highland Avenue. (Courtesy of HCPL.)

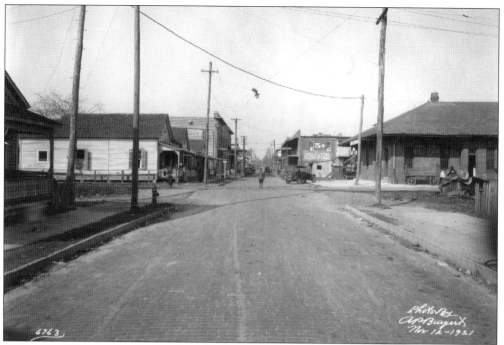

This scene showing a railroad accident at the Port Tampa docks in Port Tampa City on November 9, 1921 was likely photographed, as many accidents were, for insurance purposes. (Courtesy of HCPL.)

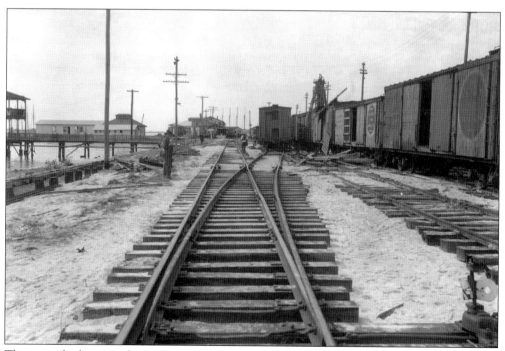

This view, looking north on Nineteenth Street at Ybor City Station and the railroad crossing, was captured on November 21, 1921. (Courtesy of HCPL.)

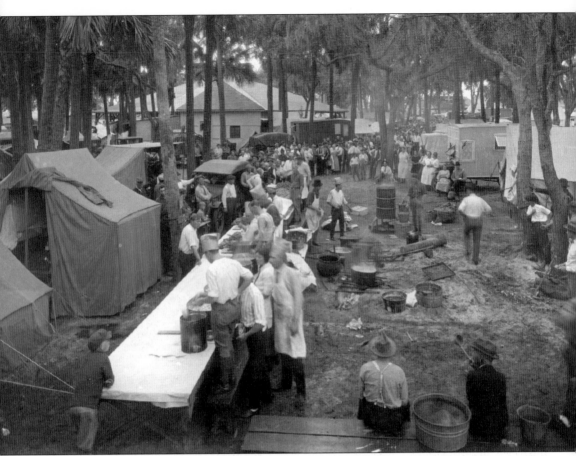

Tin Can Tourists, also known as "Tin Canners," invaded Florida in the 1920s. They traveled from place to place while living in their vehicles; sometimes they would set up a tent and stay awhile. Their unusual name was derived from the tin cans they used as hood ornaments. DeSoto Park became the headquarters for the Tin Can Tourists of the World, an organization that boasted 147,000 members before the market crashed in 1929. The Tin Can Tourists pictured above wait in a food line by tents in DeSoto Park on December 2, 1922. (Courtesy of HCPL.)

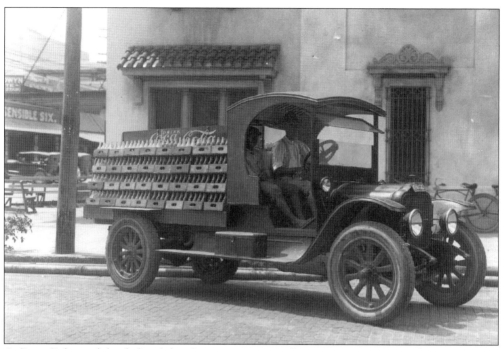

A Coca-Cola truck loaded with bottles in crates is seen here in June 1920. (Courtesy of HCPL.)

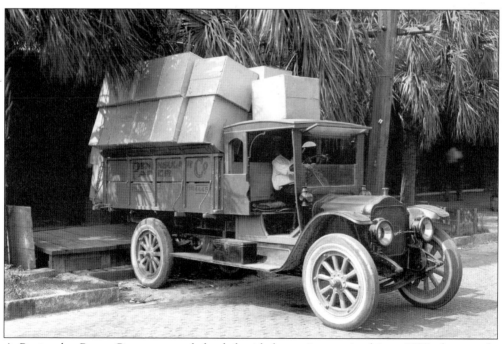

A Peninsular Paper Company truck loaded with boxes is seen in this *c.* 1920 photograph. (Courtesy of HCPL.)

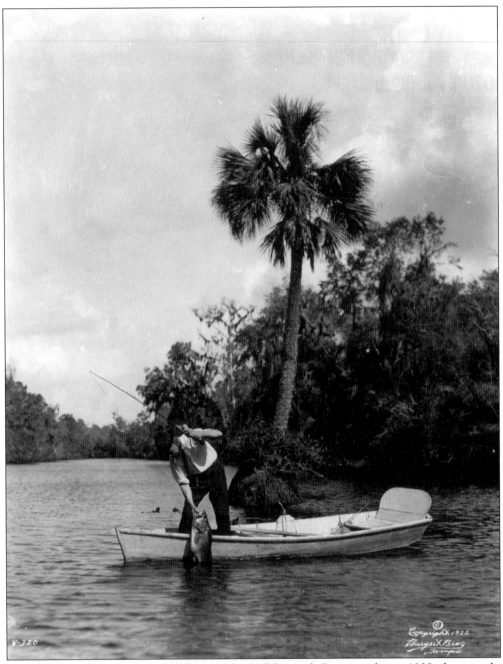

A man has caught a large-mouth bass in the Hillsborough River in this c. 1922 photograph. Fishing has always been a great pastime in Tampa, and large-mouth bass is still a favorite of anglers today. Many homes have been built along the Hillsborough River since this photograph was taken, and many homeowners enjoy fishing from their own docks. (Courtesy of HCPL.)

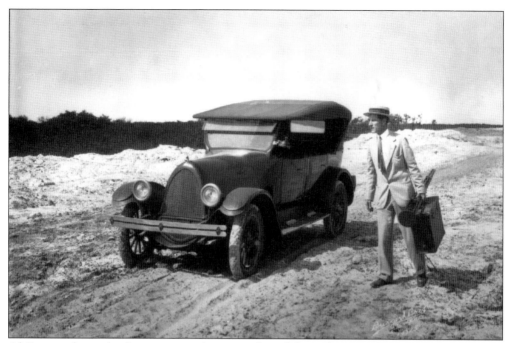

Al Burgert drove the first car onto the original mud flats of Davis Island on April 22, 1925. (Courtesy of HCPL.)

In this c. 1925 photograph, construction is underway on buildings along Davis Island Boulevard. (Courtesy of HCPL.)

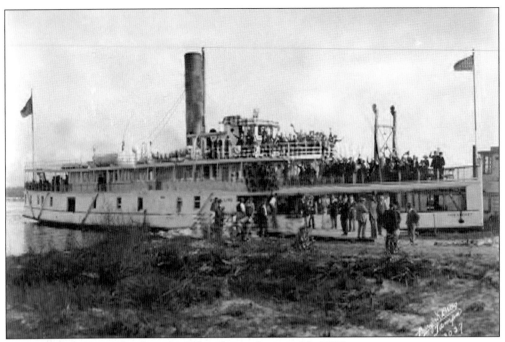

Tourists leave Davis Island on the *Pokanoket* on January 28, 1925.

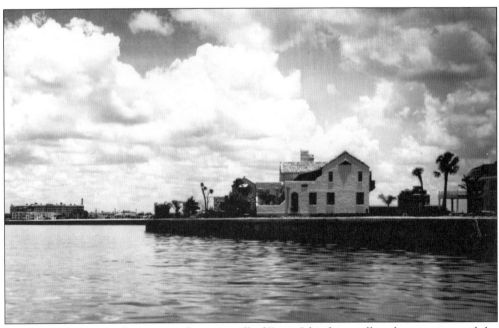

Waterfront homes on the western shore seawall of Davis Island, as well as the views toward the urban center, are seen here on June 29, 1927. (Courtesy of HCPL.)

In this photograph, Jack Dempsey and Burks L. Hamner shake hands in the ring at Davis Island's promotional fights on February 4, 1926. The exhibition fights were held to invite prospective buyers to B.L. Hamner's Forest Hills development. Hamner's motto was "Sooner or later, everyone takes to the hills." (Courtesy of HCPL.)

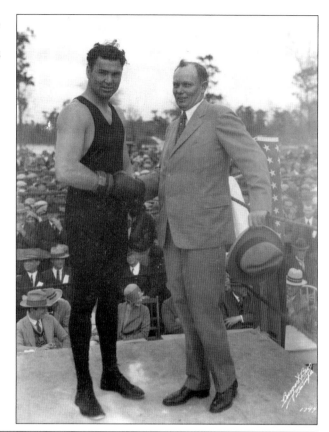

Below, stuntwoman Mabel Cody performs a ski-plane trick in a promotional event for Davis Island on April 19, 1927. (Courtesy of HCPL.)

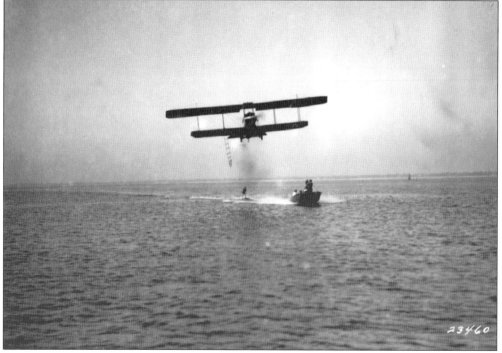

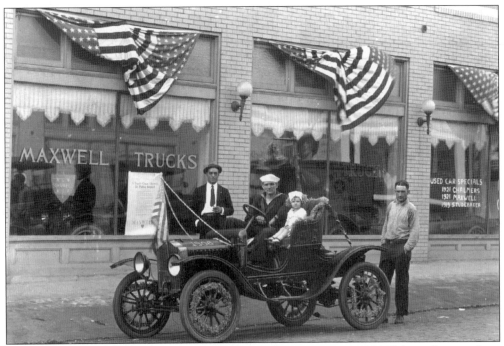

In this February 1, 1923 photograph, a child sits with some men in a 1906 Maxwell car in front of United Motors Company on Franklin Street. (Courtesy of HCPL.)

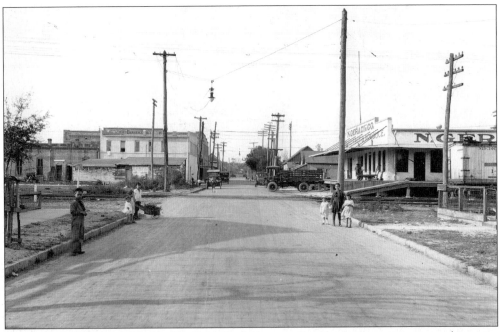

Children and businesses at the Twenty-third Street railroad crossing are seen in this view, looking north from Sixth Avenue, taken on April 1, 1920. (Courtesy of HCPL.)

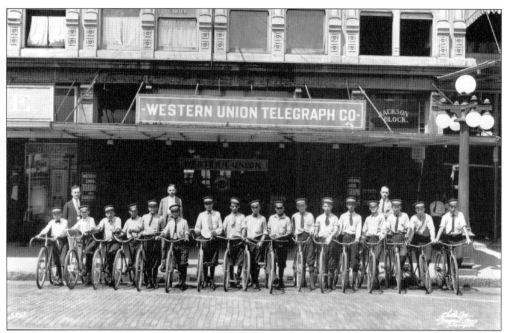

Messenger boys line up with their bicycles in front of the Western Union office at 604 Franklin Street in this August 7, 1921 photograph. These young men found it exciting and fun to ride a bicycle while earning money. Several of them became successful business owners. (Courtesy of HCPL.)

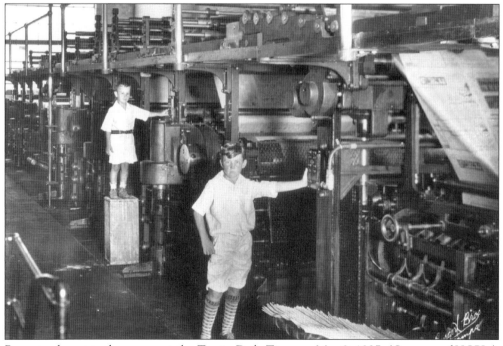

Boys stand next to the presses at the *Tampa Daily Times* on May 9, 1927. (Courtesy of HCPL.)

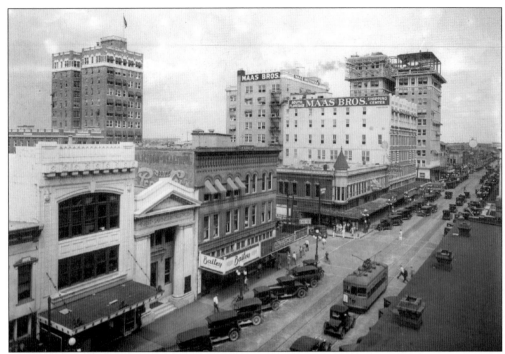

In this August 5, 1925 view, looking up Franklin Street towards its intersection with Twiggs, city traffic travels along the 500 and 600 blocks. (Courtesy of HCPL.)

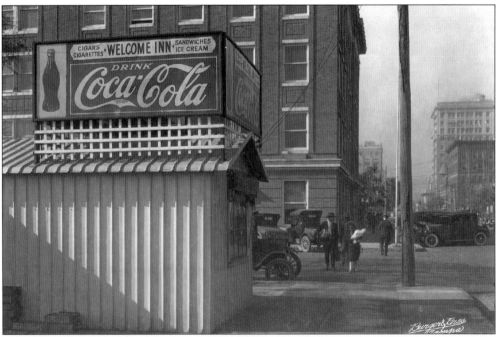

This photograph shows the Welcome Inn sandwich shack with a Coca-Cola sign on the roof at 1114 Florida Avenue on January 18, 1927. (Courtesy of HCPL.)

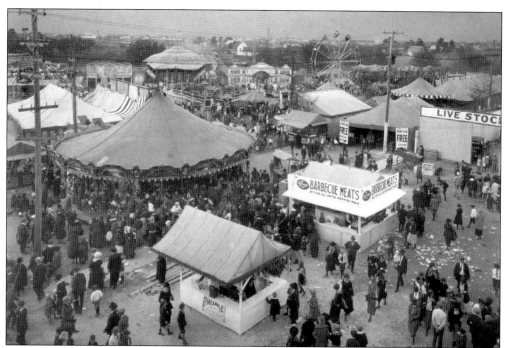

A carousel, Ferris wheel, and snack stands are visible on the midway of the Florida State Fair's 20th anniversary in this *c.* 1924 photograph. The midway was run by the Johnny Jones Shows. (Courtesy of HCPL.)

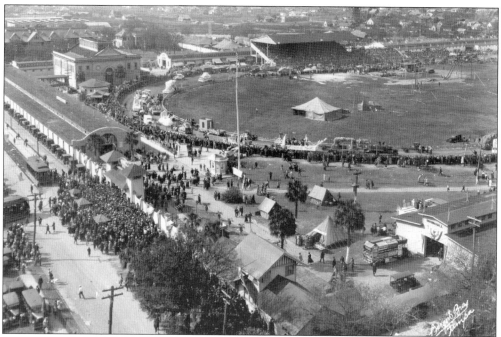

This bird's-eye view captures the scene of Gasparilla parade floats and spectators at the Florida State Fair near North Boulevard on February 9, 1926. (Courtesy of HCPL.)

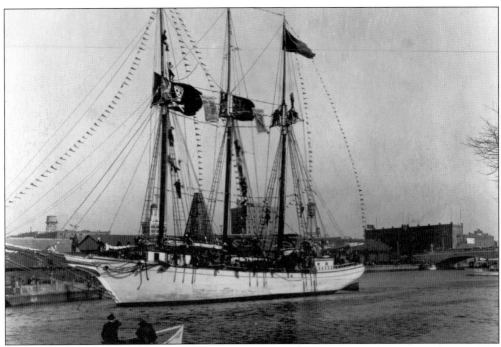

This c. 1920 Gasparilla XII Pirate Ship travels down the Hillsborough River in front of the Atlantic Coastline Freight Depot. (Courtesy of HCPL.)

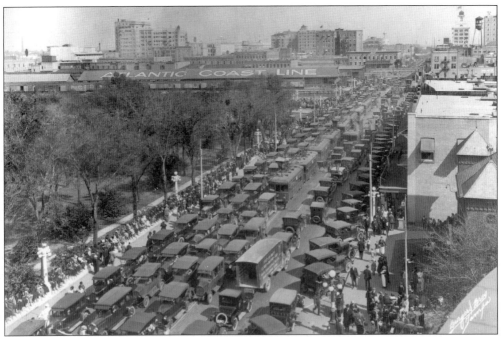

This c. 1924 photograph shows an elevated view of the Gasparilla Day traffic congestion on the 200 block of Lafayette Street near the Hillsborough River Bridge and Plant Park. (Courtesy of HCPL.)

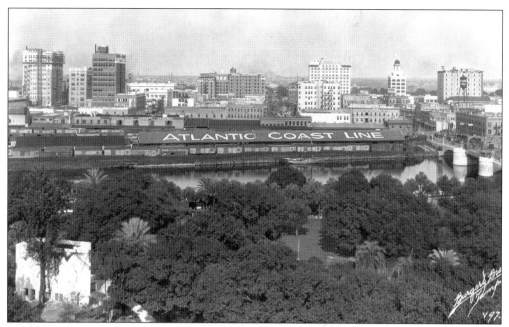

The Atlantic Coastline railroad freight depot and the downtown skyline from Plant Park are seen here on September 22, 1925. (Courtesy of HCPL.)

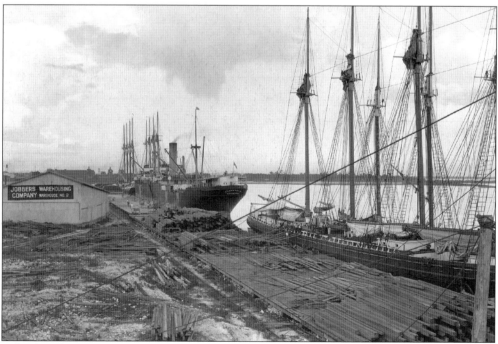

A lumber shipment sits alongside masted cargo ships at the Swann Terminal Company by the Jobbers Warehousing Company, Warehouse No. 2, in this July 11, 1924 photograph. (Courtesy of HCPL.)

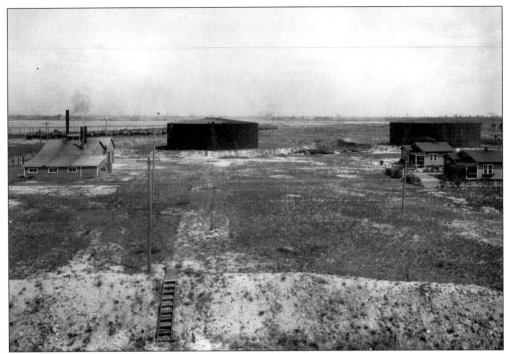

This photograph shows the Mexican Petroleum Corporation plant (Hookers Point) in March 1922. (Courtesy of HCPL.)

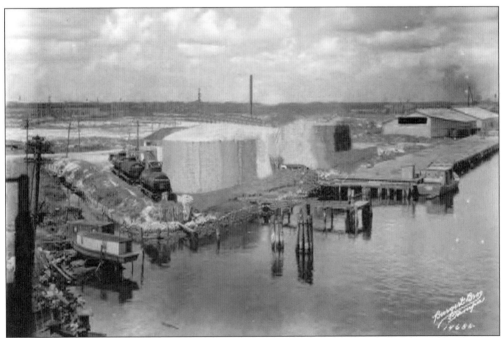

Pictured here are the Peninsula State Oil Company tanks and docks on Garrison Channel on July 3, 1925.

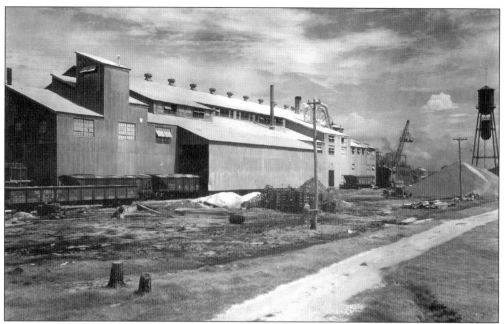

The U.S. Phosphoric Products Corporation plant, which was located in the Alafia River area of Hillsborough County, is seen here with equipment, phosphate, and dump cars on the grounds. (Courtesy of HCPL.)

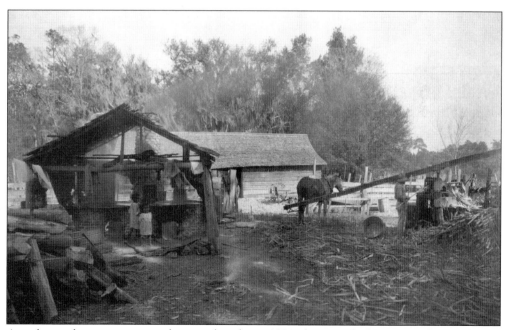

A mule grinds sugar cane on a farmstead in this *c.* 1921 photograph. (Courtesy of HCPL.)

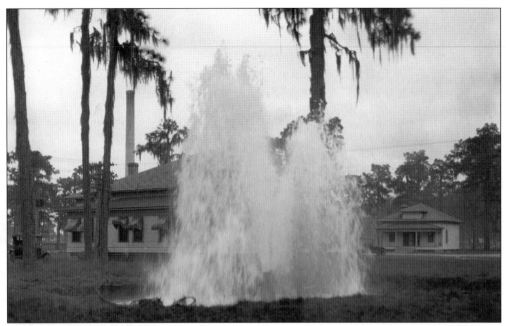

Water gushes from an uncapped wellhead in a residential neighborhood in this January 1922 photograph. (Courtesy of HCPL.)

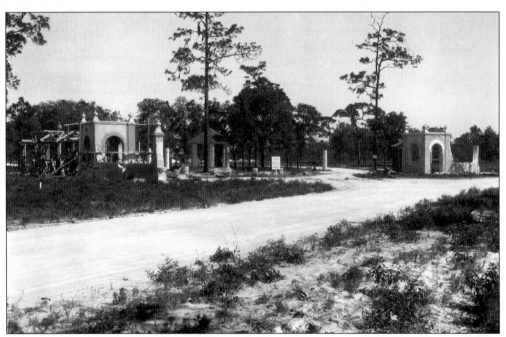

Subdivision entrance gates for a development located along rural Waters Avenue are pictured here under construction on June 9, 1926. The neighborhood was developed by the B.L. Hamner Realty Corporation. (Courtesy of HCPL.)

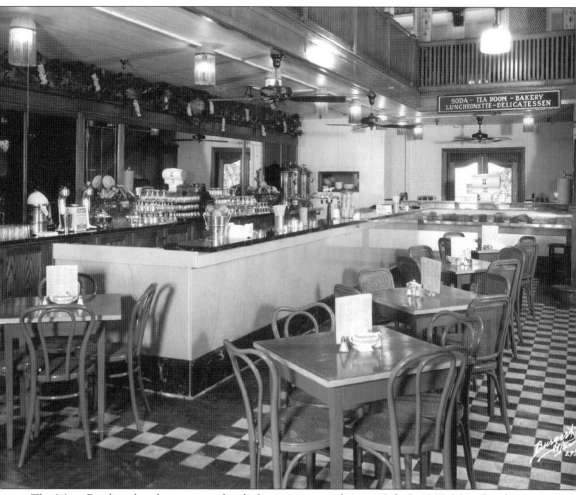

The Maas Brothers luncheonette and soda fountain is seen here on July 8, 1929. Maas Brothers Department Store was much like Macy's in New York. Patrons found the soda fountain a great place to take a break from shopping or to socialize outside of work. (Courtesy of HCPL.)

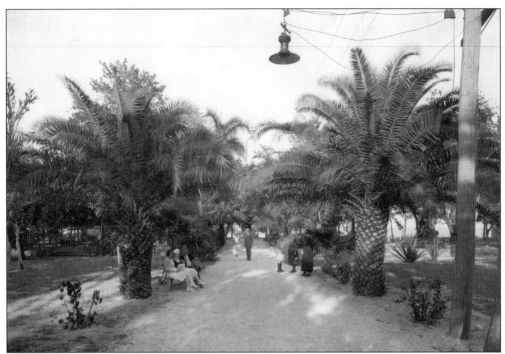

This May 15, 1922 photograph depicts the palm-lined walk at Ballast Point Park and visitors to the park relaxing on a bench. (Courtesy of HCPL.)

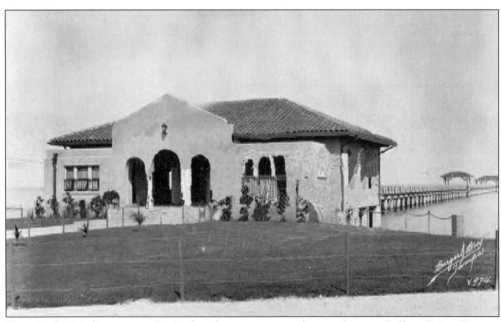

Here is the Mediterranean Revival–style entrance to the pavilion at Ballast Point Pier on August 22, 1925.

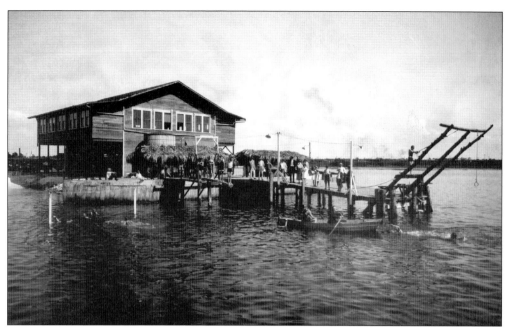

These swimmers enjoy themselves near a public bathhouse and dock at the end of Prescott Street in Port Tampa on April 21, 1925. (Courtesy of HCPL.)

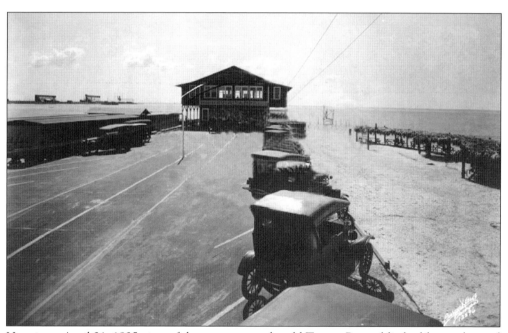

Here is an April 21, 1925 view of the entrance to the old Tampa Bay public bathhouse, located at the end of Prescott Street.

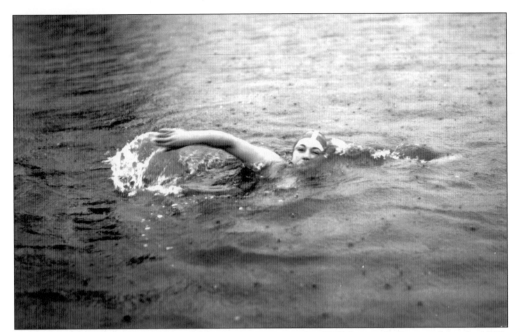

Helen Wainwright, a marathon swimmer, swims in the Hillsborough Bay in March 1925. (Courtesy of HCPL.)

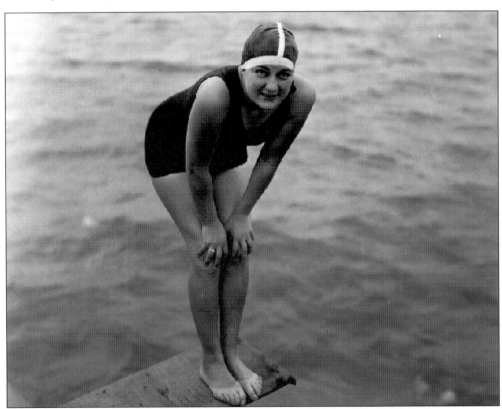

Helen Wainwright poses on a diving board on March 23, 1926. (Courtesy of HCPL.)

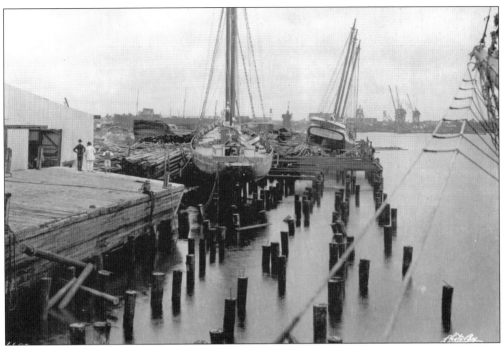

This October 25, 1921 photograph of boats at a wharf on Ybor Channel was taken after a hurricane that stayed in the state of Florida for ten days, killing eight people and causing between $2 million and $10 million in damage. (Courtesy of HCPL.)

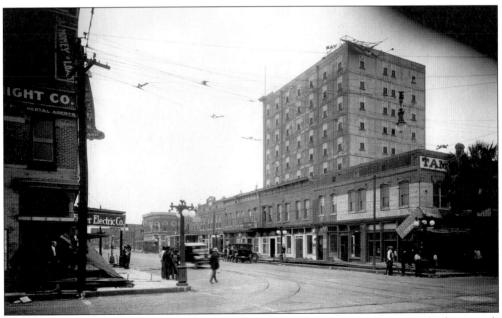

The hurricane damage on Franklin Street is clear in this October 25, 1921 view, looking south from Lafayette Street. (Courtesy of HCPL.)

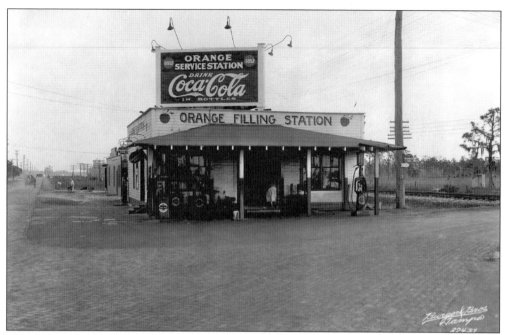

The Orange Service Station with its Coca-Cola sign on the roof is located at Six Mile Creek Railroad Crossing and is pictured here c. 1927. (Courtesy of HCPL.)

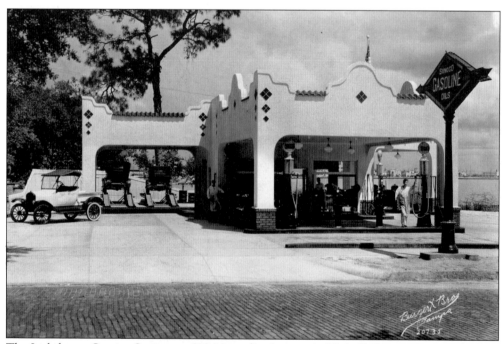

The Lighthouse Service Station at 620 Magnolia Avenue in Hyde Park was photographed on August 23, 1926. (Courtesy of HCPL.)

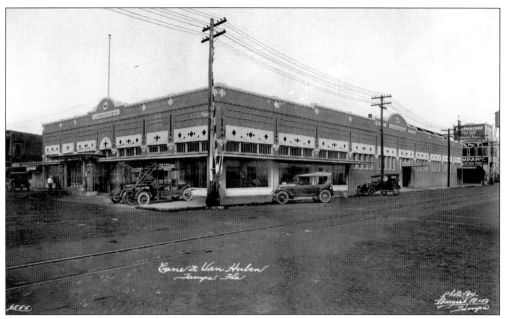

The Cane & Van Huben Towing Company, located at 805 Florida Avenue, was the subject of this *c.* 1921 photograph. (Courtesy of HCPL.)

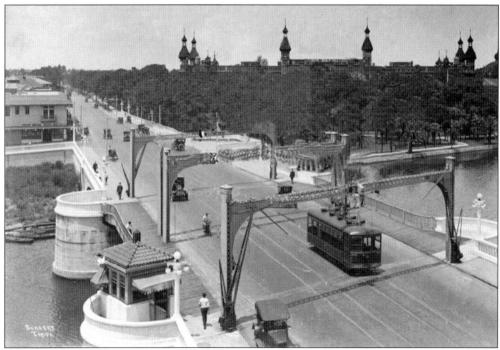

Automobile and streetcar traffic travels down Lafayette Street Bridge in this view looking west toward the Tampa Bay Hotel (now the University of Tampa), *c.* 1921.

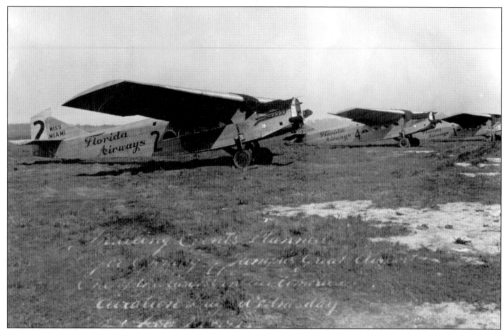

This photograph shows three Florida Airways planes parked in close proximity at Drew Field. The caption on the photograph reads, "Thrilling Events Planned for Opening of Tampa's Greatest Airport, One of the Largest in All America, Aviation Day, Wednesday, February 22, 1928." (Courtesy of HCPL.)

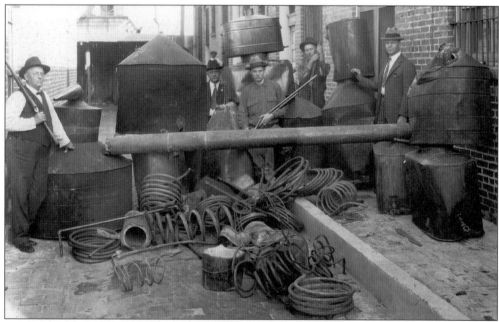

Hillsborough County sheriffs are seen here with a confiscated moonshine still. Historical speculation is that these bootleggers were busted because they failed to pay off certain authorities. The photograph was taken behind the county jail on January 10, 1925. (Courtesy of HCPL.)

Six

1930s

*T*he operation of a successful business after the Great Depression began was a difficult struggle, but Tampa survived it and even arrived at the other side of the era in better shape than before. Privately owned automobiles pushed the streetcar out of business and many successful businesses found themselves going from great financial freedom to poverty. Most of the cigar manufacturers managed to survive this dark period. For many, Tampa was their stability until the flood of 1934. Again, many businesses found themselves in peril, but the camaraderie within the community helped each individual, each family, and each business rebuild and move forward.

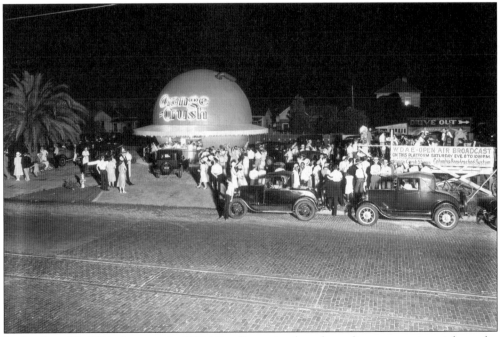

In this June 20, 1931 photograph, WDAE radio station broadcasts live on opening night at the Frosty Morning Shop, located at 1301 Grand Central Avenue. (Courtesy of HCPL.)

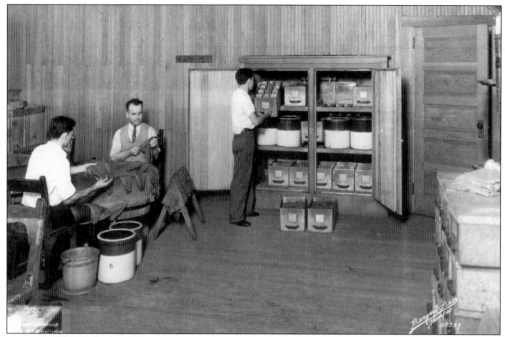

Cigar workers select tobacco leaves on October 1, 1930. Cigar makers took pride in hand-rolling their cigars, and by doing so, kept people working and were able to forgo the cost of expensive machinery. (Courtesy of HCPL.)

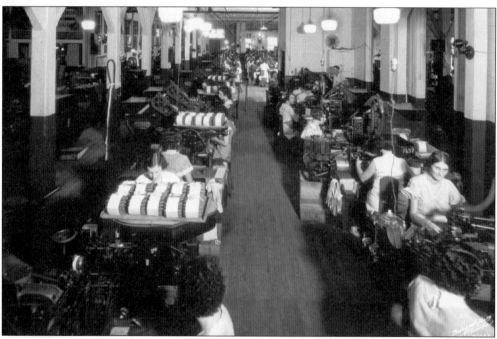

The interior of the Havatampa Cigar Company is filled with workers and machines making cigars in this July 13, 1933 photograph. (Courtesy of HCPL.)

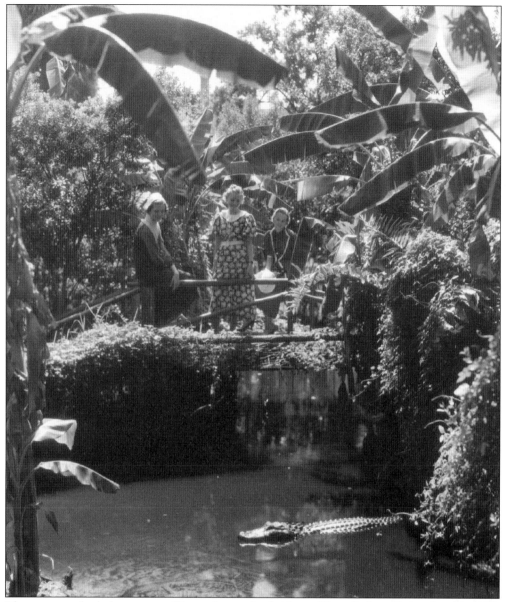

Three women look down at an alligator from a footbridge in Plant Park on September 11, 1936. Alligators have always been abundant in the state of Florida, and Plant Park was a lovely place to see them in their natural habitat. Even though Plant Park was near the downtown area, it was secluded enough to be a place for a nice stroll, a place to think, and a place to gain perspective on the hustle and bustle of city living. (Courtesy of HCPL.)

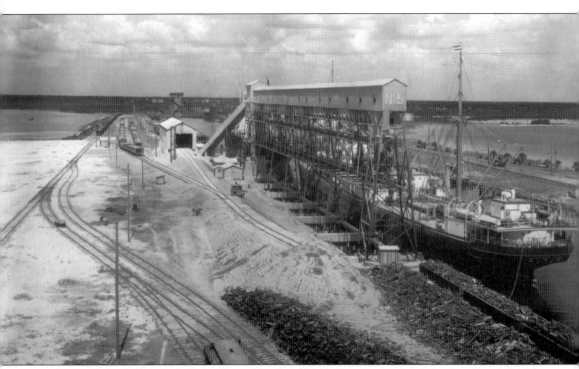

The Freighter *Asuku Maru* is seen here at a phosphate elevator next to the railroad on June 19, 1936. Phosphate was one of the natural resources that helped turn Tampa into a thriving community, and phosphate mines such as this one still exist on the outskirts of Tampa. These mines provide 75 percent of the phosphate used for fertilizer in the United States, and they continue to be essential to the economy in Tampa Bay. (Courtesy of HCPL.)

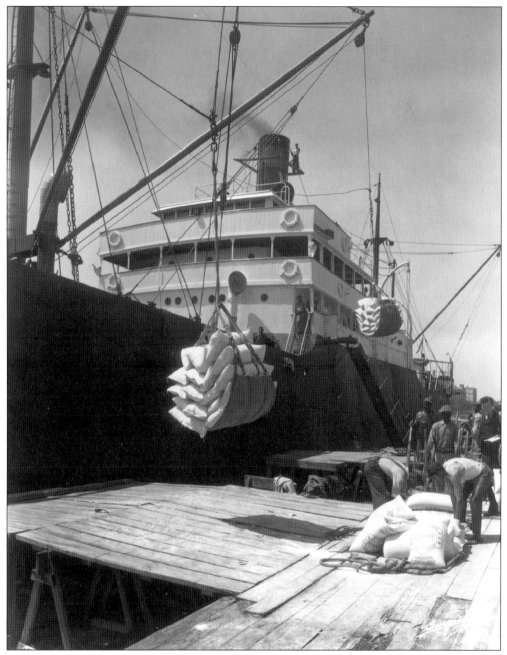

In this photograph, taken on April 3, 1937, sacks of sugar are being unloaded from a docked cargo ship. (Courtesy of HCPL.)

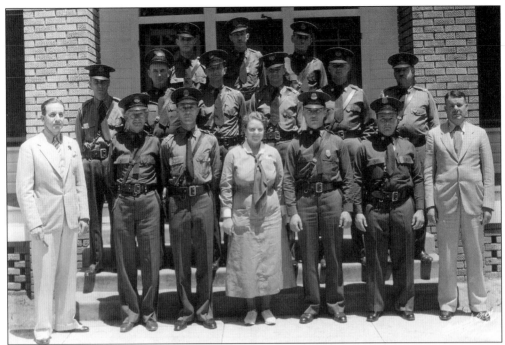

An American Red Cross Boarder Patrol group is seen here on May 17, 1937. (Courtesy of HCPL.)

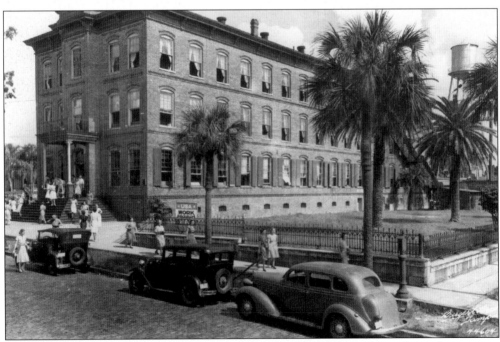

The WPA sewing room facility, seen here on October 30, 1939, was housed in a former cigar factory on the southeast corner of Twentieth Street and Twelfth Avenue in Ybor City. (Courtesy of HCPL.)

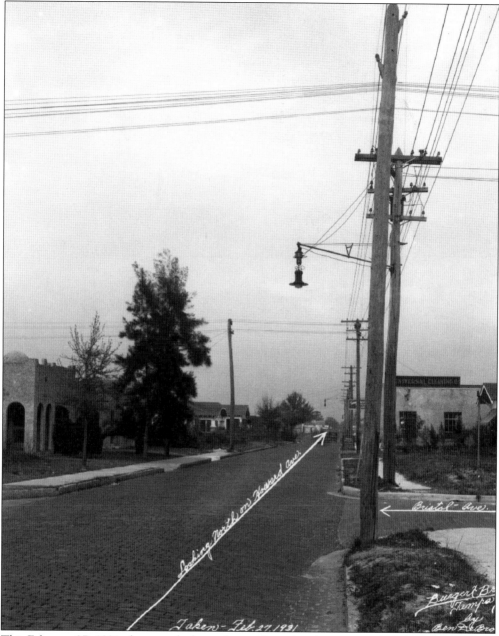

This February 27, 1931 photograph shows the residential and commercial Hyde Park at the 800 block of Howard Avenue at its intersection with Bristol Avenue. (Courtesy of HCPL.)

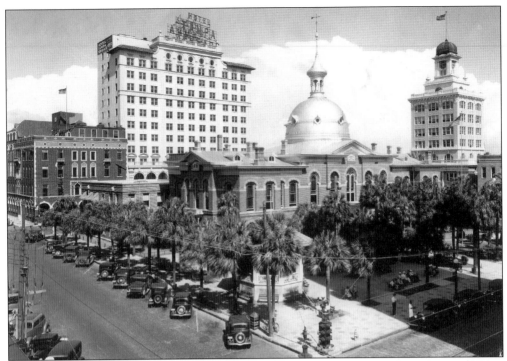

The Hillsborough County Courthouse, which stands at the corner of Franklin and Madison Streets, is pictured here with city hall and the Hotel Tampa Terrace visible in the background on May 10, 1935. (Courtesy of HCPL.)

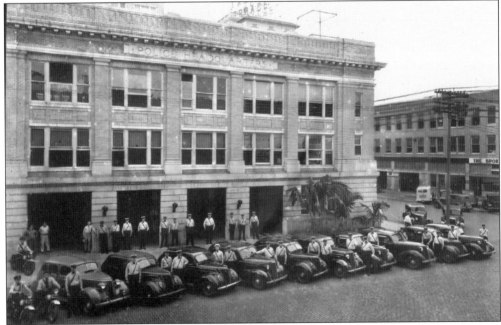

Officers, automobiles, and a few motorbikes are pictured in front of the multi-story Tampa Police Department Headquarters building at 300 Jackson Street on July 17, 1939. (Courtesy of HCPL.)

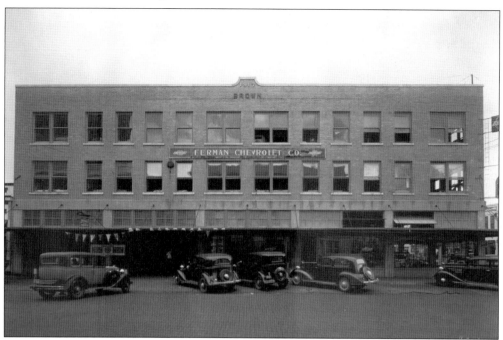

The Ferman Chevrolet Company at 1428 Florida Avenue is seen here on July 13, 1935. (Courtesy of HCPL.)

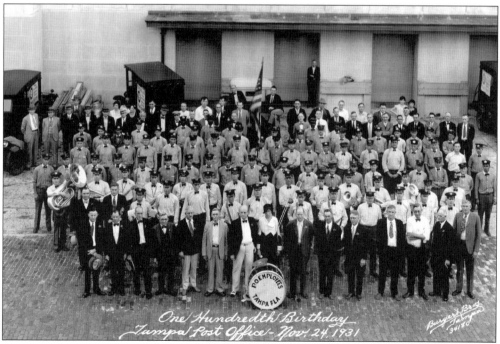

Postal employees celebrated the 100th anniversary of the Tampa Post Office on November 24, 1931 and stopped just long enough to pose for this photograph. (Courtesy of HCPL.)

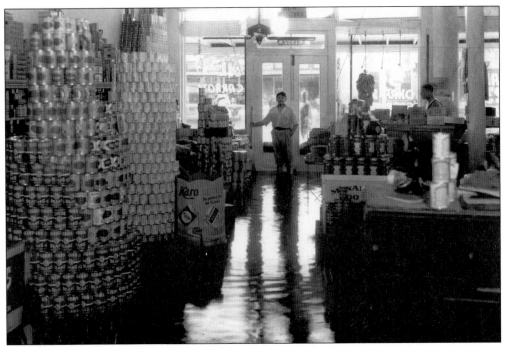

The flooded interior of Hyman's Grocery, located at 1500 Grand Central Avenue, is seen in this photograph taken on June 13, 1934. (Courtesy of HCPL.)

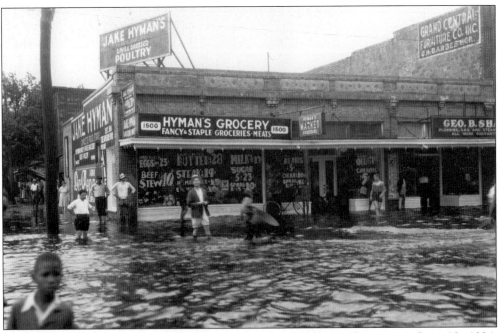

Residents wade through the flooded street in front of Hyman's Grocery on June 13, 1934. (Courtesy of HCPL.)

This photograph shows the Bay View Hotel at 208 Jackson Street in the downtown section of Tampa on April 19, 1930. (Courtesy of HCPL.)

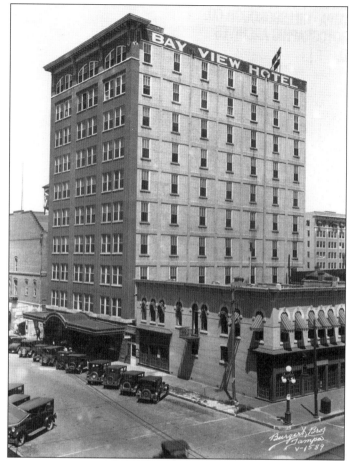

The Firestone Service Station Inc. at 900 East Lafayette Street featured gas pumps under a covered service area and a building with a tower. It is seen here on July 29, 1933. (Courtesy of HCPL.)

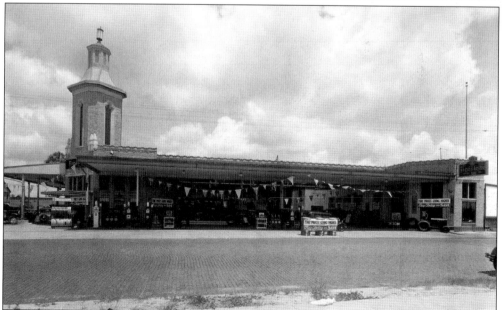

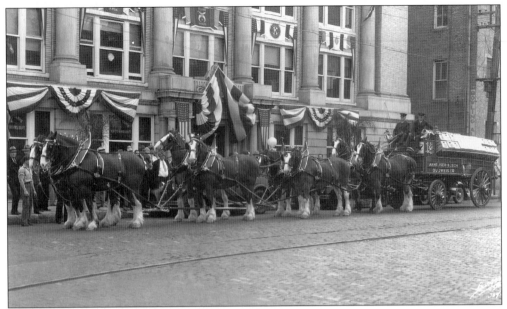

Clydesdale horses and the Anheuser-Busch wagon are pictured here on January 28, 1934 in front of Tampa City Hall on Lafayette Street. The Anheuser-Busch Clydesdales were introduced to August A. Busch Sr., president of Anheuser-Busch, Inc., by his son on April 7, 1933. Great care is taken with the team housed at Busch Gardens. (Courtesy of HCPL.)

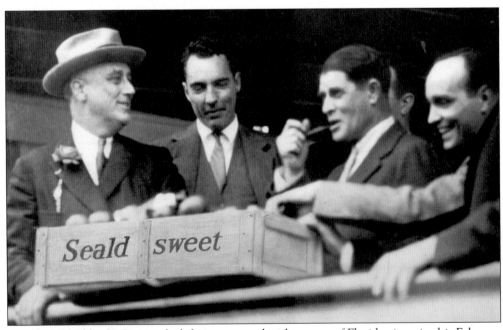

President Franklin D. Roosevelt, left, is presented with a crate of Florida citrus in this February 1933 photograph. (Courtesy of HCPL.)

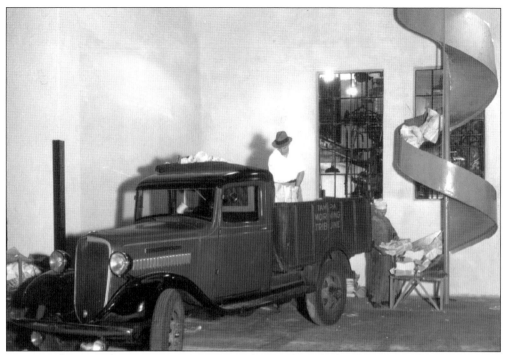

Tampa Tribune employees remove newspapers from a chute for loading onto a delivery truck in this June 15, 1935 photograph. (Courtesy of HCPL.)

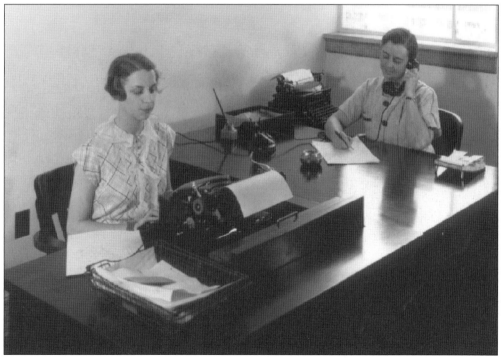

Society editors at the *Tampa Tribune* are hard at work in this photograph, taken on June 8, 1935. (Courtesy of HCPL.)

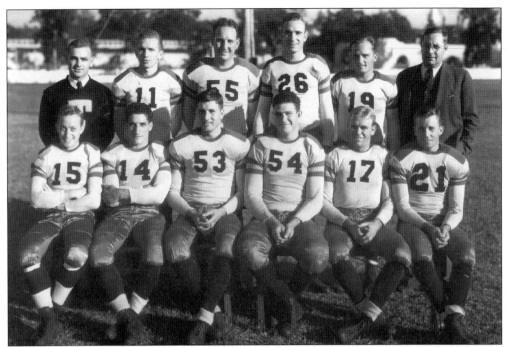

Graduating football players at the University of Tampa pose on the field for this December 3, 1936 photograph. (Courtesy of HCPL.)

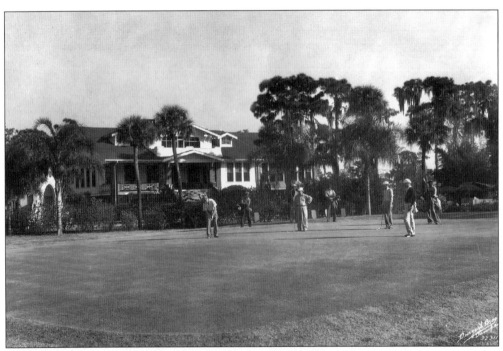

In this photograph, golfers play on the 18th green at the Palma Ceia Golf Club on December 18, 1934. (Courtesy of HCPL.)

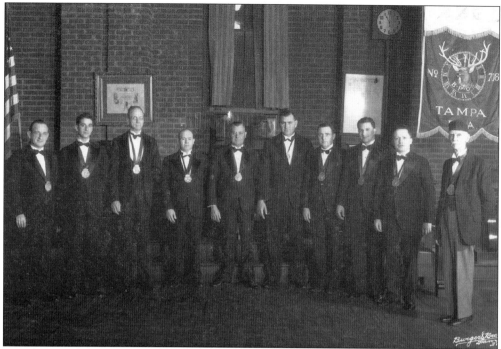

In this *c.* February 1934 photograph, officers of the Elk's Club Lodge No. 708, are adorned in tuxedos and the medals of their office. (Courtesy of HCPL.)

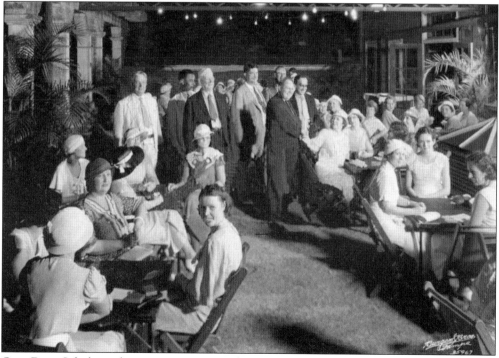

Gov. Dave Scholtz and company enjoy a card party at the Elk's Club on June 28, 1933.

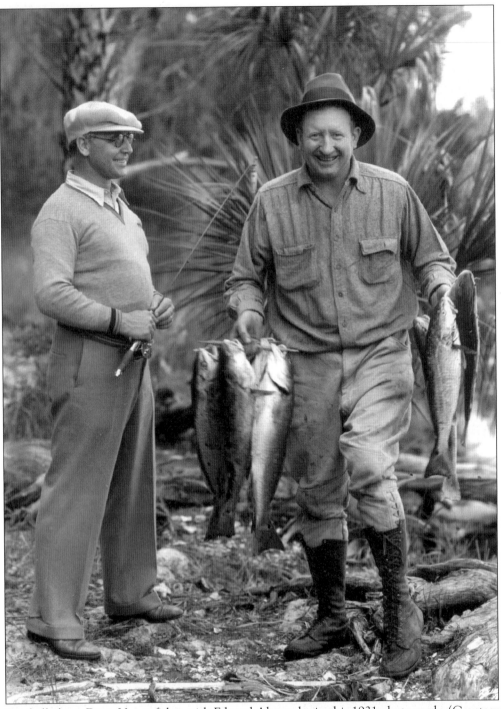

Baseball player Dazzy Vance fishes with Edward Alexander in this 1931 photograph. (Courtesy of HCPL.)

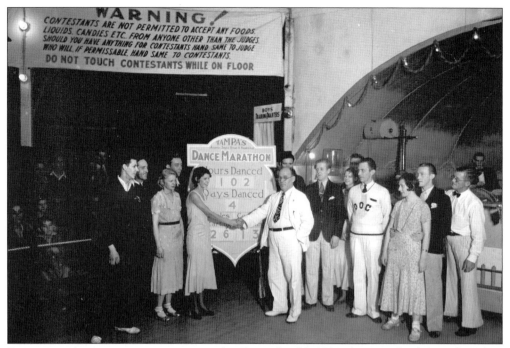

Dance marathon contestants are seen in this December 30, 1931 photograph taken at the Silver Star Ballroom in Sulphur Springs. Marathon dances became a national fad and promoters offered cash prizes to attract contestants. (Courtesy of HCPL.)

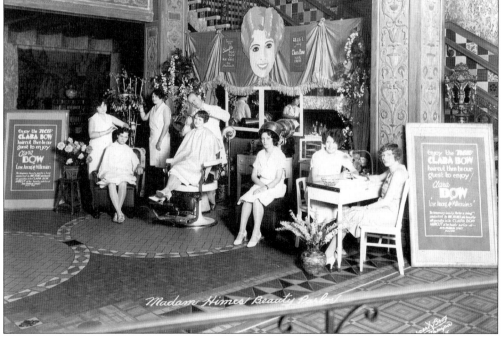

In this photograph, women are having their hair styled at Madam Himes Beauty Parlor , which advertises the "Clara Bow haircut," in the lobby of the Tampa Theatre on July 15, 1930. (Courtesy of HCPL.)

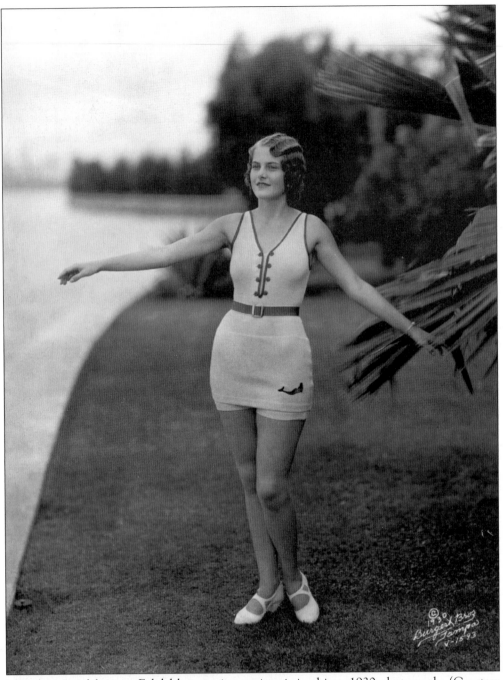

Miss America, Margaret Eckdahl, poses in a swimsuit in this c. 1930 photograph. (Courtesy of HCPL.)

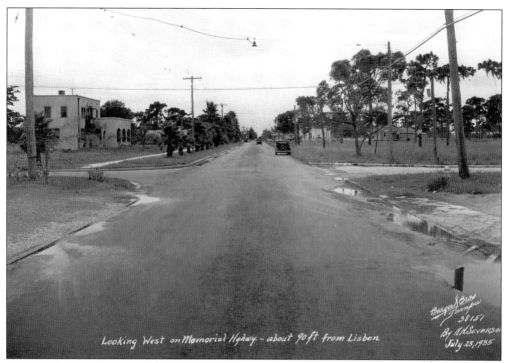

Memorial Highway appears in this July 23, 1935 view looking west at the intersection of Lisbon Avenue. (Courtesy of HCPL.)

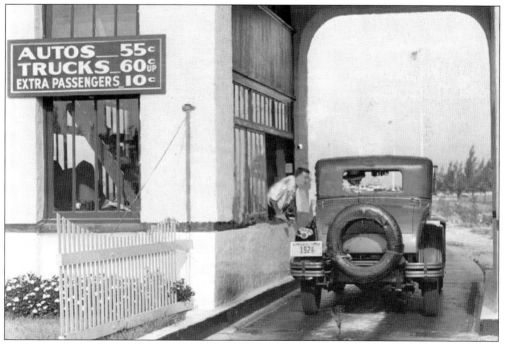

An automobile with license plate number "1926" pulls up to the toll gate on the Gandy Bridge on May 22, 1930.

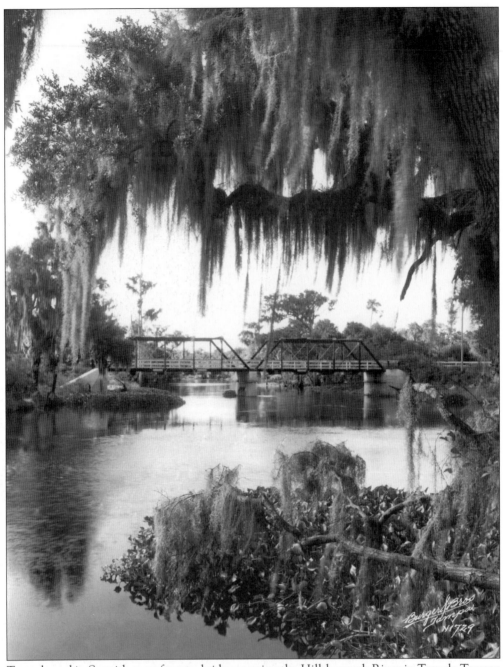

Trees draped in Spanish moss frame a bridge crossing the Hillsborough River in Temple Terrace in this photograph taken September 10, 1936. (Courtesy of HCPL.)

Seven

1940s

During the 1940s, World War II had a great impact on the United States and the Tampa Bay region as well. For the first time, women found themselves in the workforce because their husbands, brothers, and sons were being shipped overseas to fight for the freedom of all. Not only were women working, they were also going to college. Scholarship programs for women were on the increase, and by the time the war ended, many women did not want to return to their homemaking duties. Women's rights became a hot topic for several years afterwards.

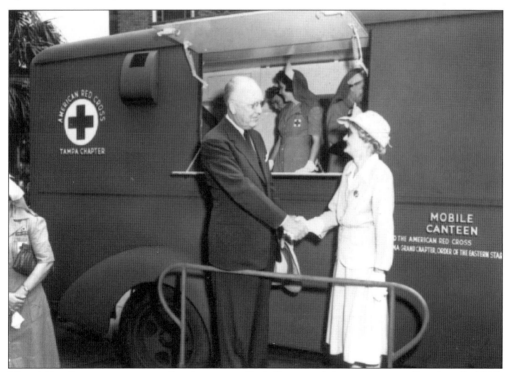

Mrs. ? Reed greets a man at the American Red Cross mobile canteen on October 8, 1943. (Courtesy of HCPL.)

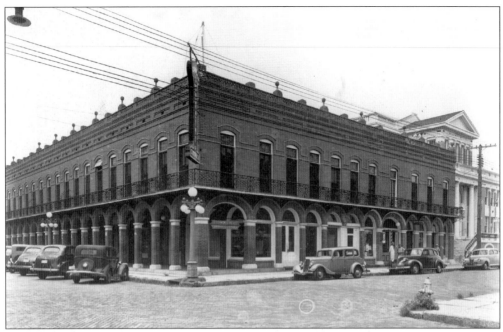

The Ybor City Chamber of Commerce, located at 1320 Ninth Avenue on the corner of Fourteenth Street, is a two-story brick building with a ground floor arcade and wrought-iron balcony. It is seen here on August 18, 1941. (Courtesy of HCPL.)

This view of the H.T. Lykes Building, located on the 200 block of Franklin Street, was photographed on November 4, 1946. (Courtesy of HCPL.)

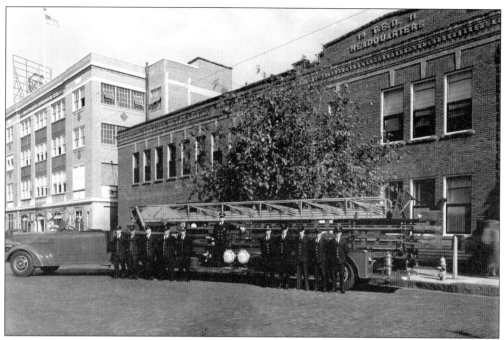

The Hook & Ladder Company No. 1, located in front of the Fire Department Headquarters building at 720 Zack Street, is seen here on August 3, 1944. (Courtesy of HCPL.)

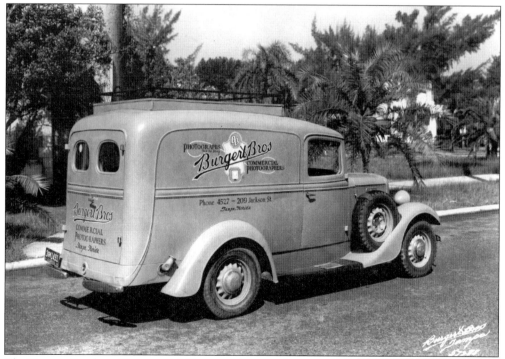

The Burgert Brothers Commercial Photographers truck is seen here on July 27, 1945. (Courtesy of HCPL.)

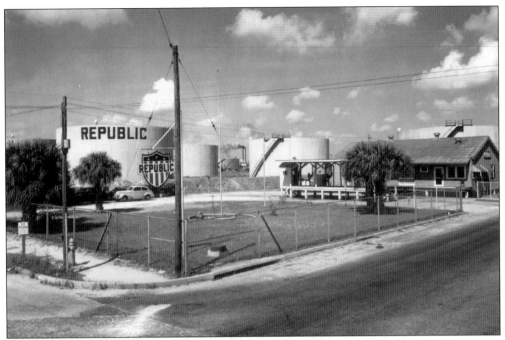

The oil storage tanks at the Republic Oil Refining Company are located at Grant and Twentieth Streets and are pictured here on October 22, 1946. (Courtesy of HCPL.)

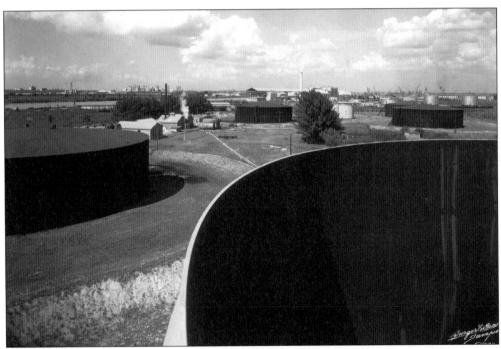

The oil storage tanks at the American Oil Company facilities were photographed here on February 16, 1945. (Courtesy of HCPL.)

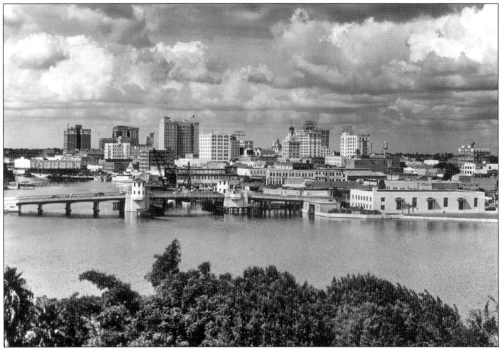

This photograph provides a skyline view, looking northeast from Davis Island, of the Platt Street Bridge, the waterfront, and the downtown area on September 20, 1940. (Courtesy of HCPL.)

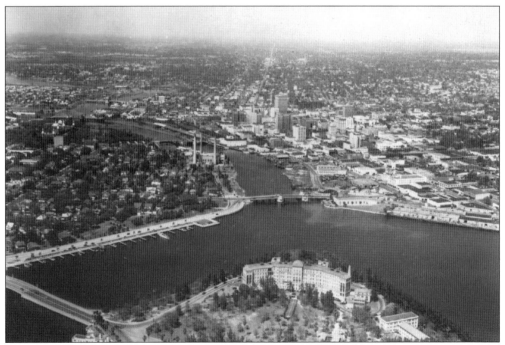

This view looking north from Davis Island shows downtown and Hyde Park at the mouth of the Hillsborough River on November 2, 1947. (Courtesy of HCPL.)

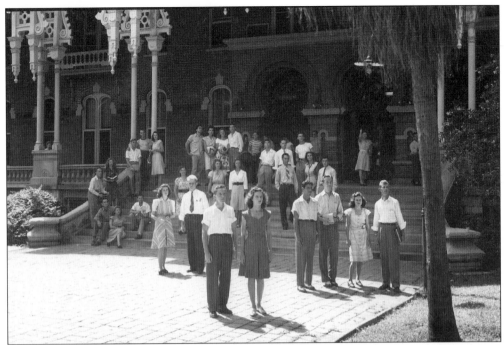

In this September 20, 1946 photograph, college students stand on the main steps of Plant Hall at the University of Tampa. (Courtesy of HCPL.)

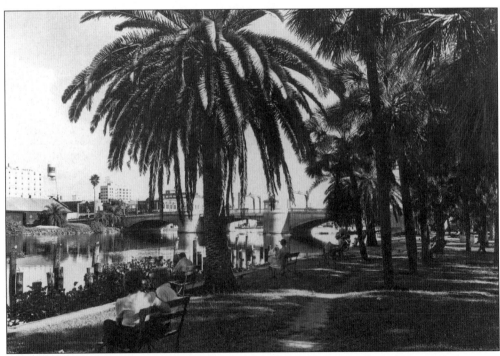

Visitors to Plant Park rest on the benches placed along the bank of the Hillsborough River on October 28, 1947. (Courtesy of HCPL.)

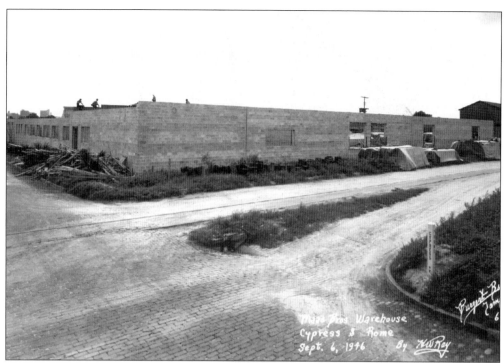

The Maas Brothers Department
Store Warehouse, located at Cypress
and Rome Avenues, is seen above
on September 6, 1946. (Courtesy
of HCPL.)

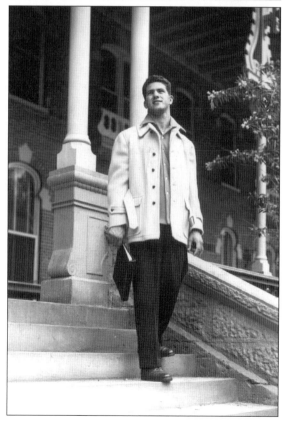

A male model for Maas Brothers poses
on the steps of the University of
Tampa on August 18, 1946. (Courtesy
of HCPL.)

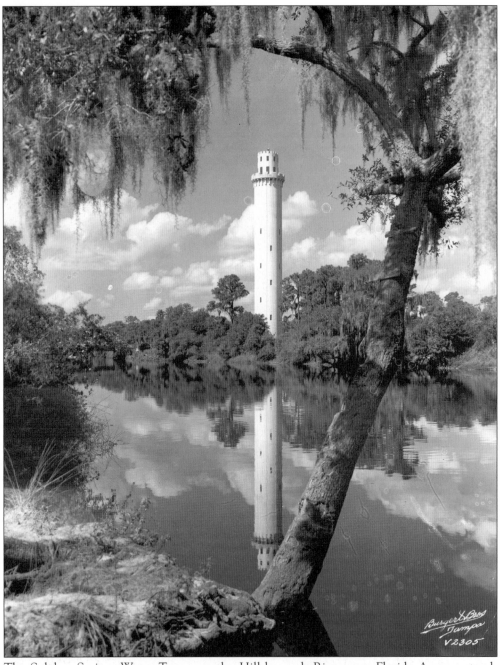

The Sulphur Springs Water Tower on the Hillsborough River near Florida Avenue stands straight and tall in this October 15, 1945 image. (Courtesy of HCPL.)

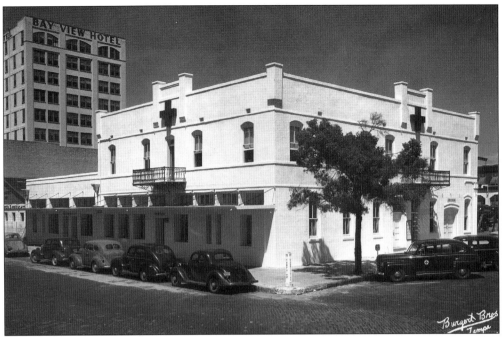

The Red Cross Building on Tampa Street is pictured above on April 3, 1946. (Courtesy of HCPL.)

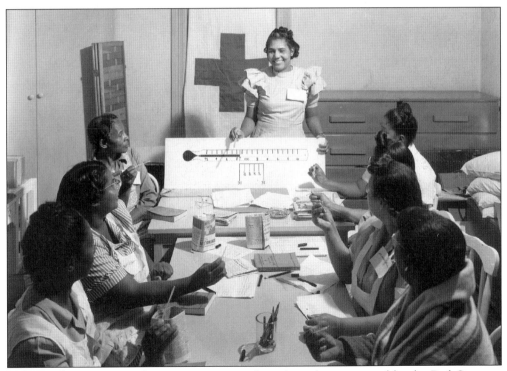

Helen Wilson presents a lesson to nursing students in a class sponsored by the Red Cross on March 8, 1949. (Courtesy of HCPL.)

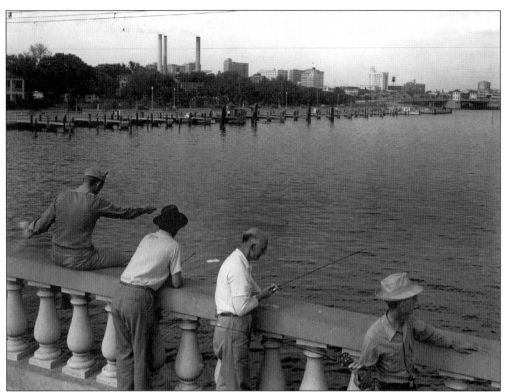

Men fish from the Davis Island Bridge with boat docks and downtown Tampa in the background in this March 12, 1946 scene. (Courtesy of HCPL.)

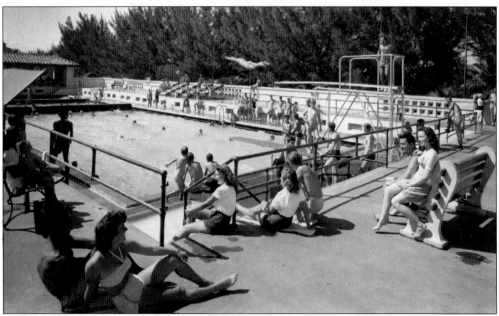

People often came to the Davis Island swimming pool, seen above on June 1, 1947, to sunbathe, swim, and visit with their neighbors. (Courtesy of HCPL.)

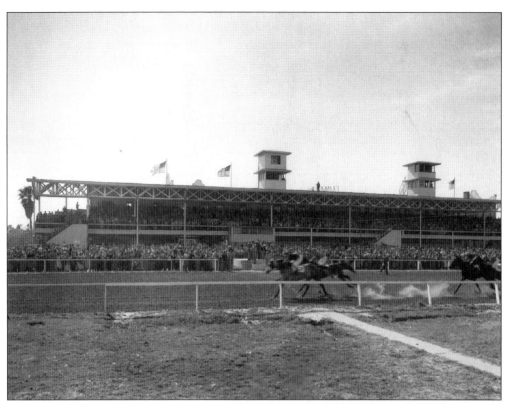

Above, racehorses cross the finish line in front of a grandstand of onlookers at Sunshine Park on March 22, 1947. (Courtesy of HCPL.)

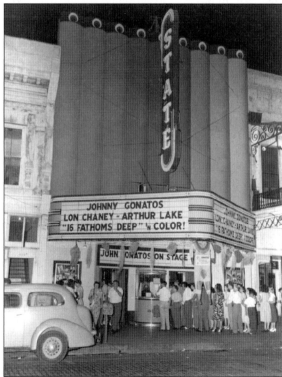

In this July 20, 1948 image, movie patrons wait in line to purchase tickets to the film *16 Fathoms Deep*, a color picture showing at the State Theatre at 1003 Franklin Street. (Courtesy of HCPL.)

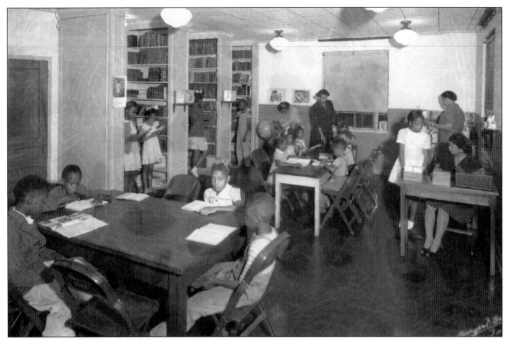

Children use educational materials at the North Boulevard Homes Library facility in this photograph taken on November 21, 1945. (Courtesy of HCPL.)

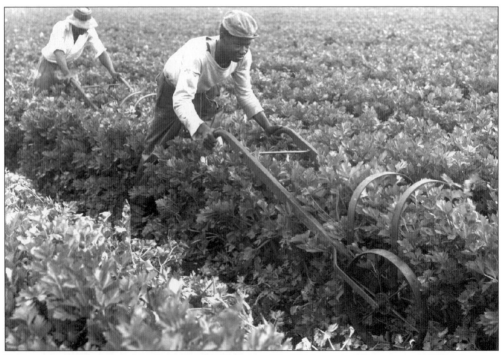

Farm workers labor in celery fields in this February 22, 1945 scene. (Courtesy of HCPL.)

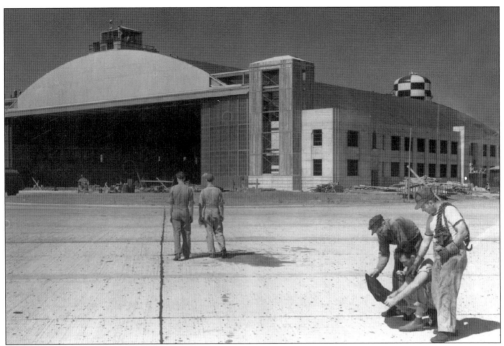

Construction of the MacDill Air Force Base hangar is finally nearing completion in this June 3, 1941 photograph, taken just prior to the United States's engagement in World War II. (Courtesy of HCPL.)

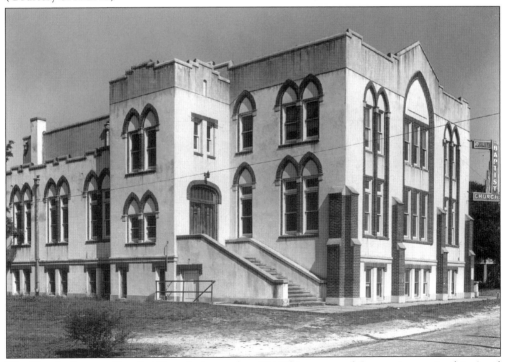

The Tenth Avenue Baptist Church, located at 204 Thirty-second Street, is seen in this April 1946 photograph. (Courtesy of HCPL.)

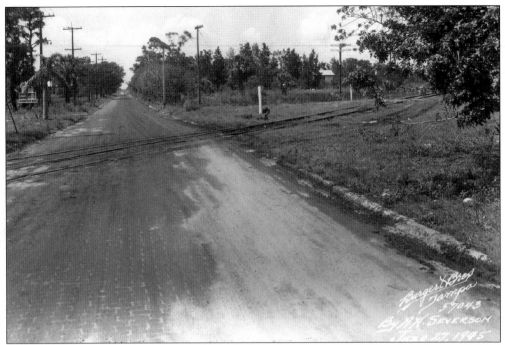

This view from a railroad crossing shows an Atlantic Coastline vessel coming into Port Tampa City on June 27, 1945. (Courtesy of HCPL.)

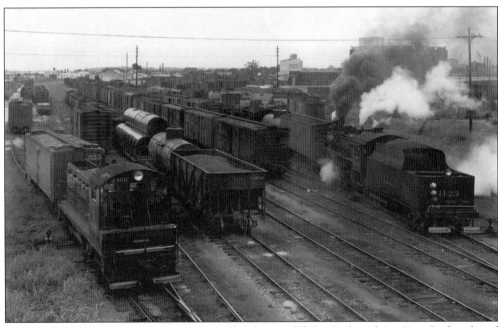

In this July 27, 1948 view, locomotives and freight cars fill the Seaboard Air Line Railroad yard south of the viaduct in the estuary zone. (Courtesy of HCPL.)

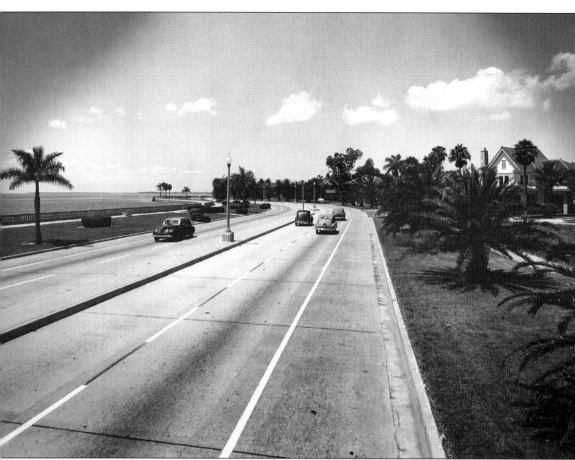

This view, looking southwest from Magnolia Avenue, shows the automobile traffic on Bayshore Boulevard on June 23, 1948. Bayshore Boulevard provides a tantalizing view of Tampa Bay, and the boardwalk lining the mouth of the bay is a magnet for walkers, runners, and bicyclists. Today, Bayshore Boulevard is a six-lane roadway for most of its stretch from Tampa General Hospital to MacDill Air Force Base. (Courtesy of HCPL.)

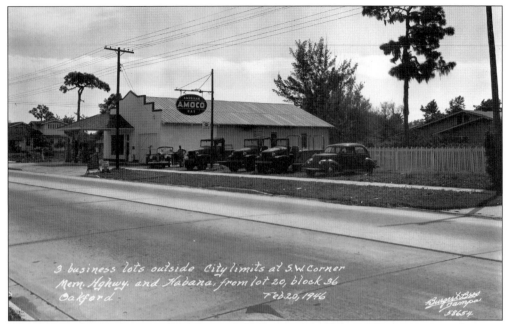

The Amoco Gas Station at 602 Memorial Highway near Habana Avenue is seen here on February 20, 1946. (Courtesy of HCPL.)

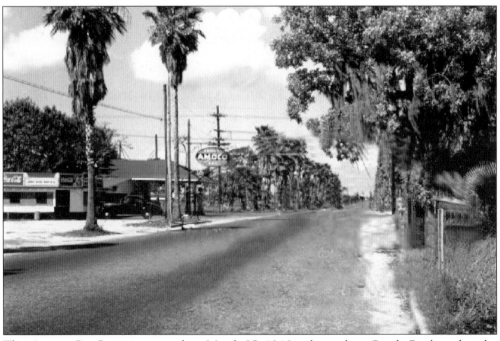

This Amoco Gas Station, pictured on March 25, 1946, is located on Gandy Boulevard at the intersection of MacDill Avenue.

Eight
1950s

*T*he 1950s brought more growth to Tampa with the founding of the University of South Florida in 1956. Three years later August Busch Jr. opened Busch Gardens on 15 acres of reclaimed sandy wasteland, not far from the still growing University of South Florida. Both facilities broadened the economy for Tampa by creating thousands of new jobs. In addition, once the University of South Florida began classes, many students were just a short distance away from Busch Gardens where they found part-time jobs during the summer months. The University of South Florida offers many degree programs and has become one of the largest medical teaching facilities in the country.

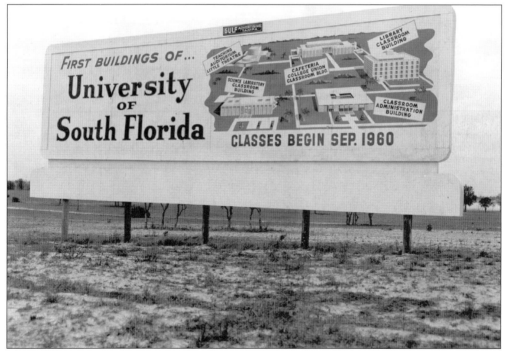

This billboard depicts the future site of the University of South Florida and was photographed on February 25, 1959. (Courtesy of HCPL.)

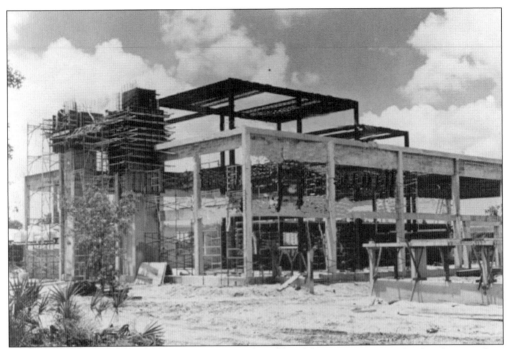

Pictured above is the beginning of construction on the University of South Florida's Student Union Building in May 1959.

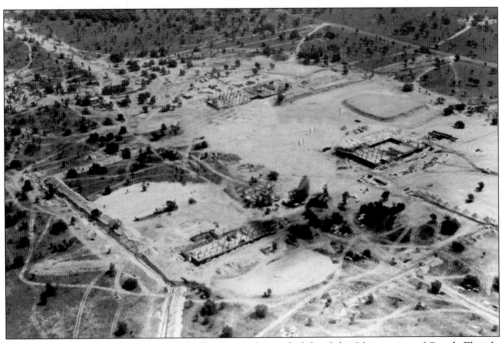

Taken from the air, this photograph illustrates the early life of the University of South Florida in May 1959.

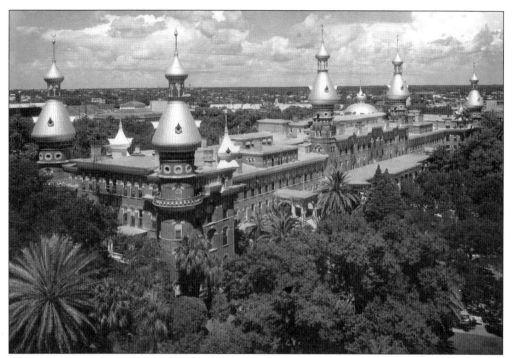

The University of Tampa's roofline with its striking minarets can be seen here from across Plant Park in October 1955. (Courtesy of HCPL.)

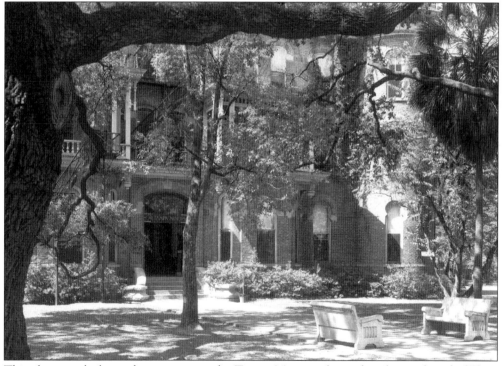

This photograph shows the entrance to the Tampa Museum, located at the south end of Plant Hall, at the University of Tampa on July 26, 1950. (Courtesy of HCPL.)

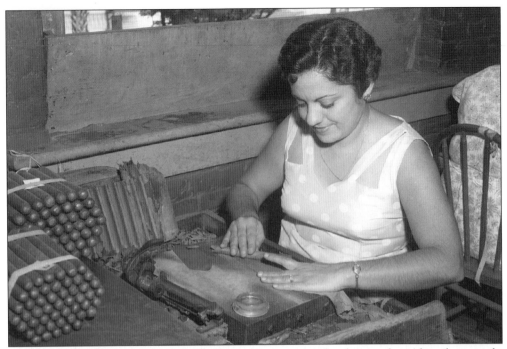

A female cigar roller with Corral Wodiska y Compania is hard at work in this photograph, taken on October 6, 1957. (Courtesy of HCPL.)

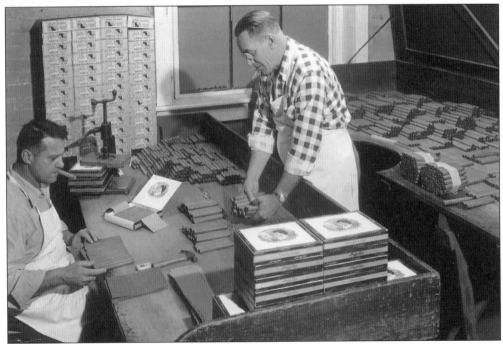

In the photograph above, men smoke cigars while packing Corona Larga boxes at Garcia y Vega manufacturers in March 1958. (Courtesy of HCPL.)

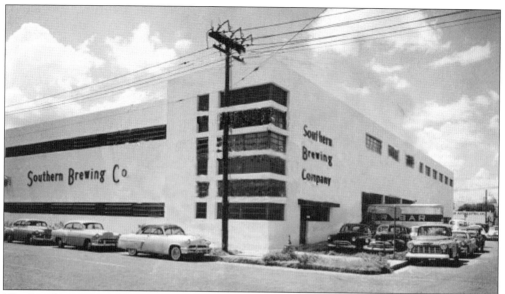

The Southern Brewing Company is located at 700 Zack Street.

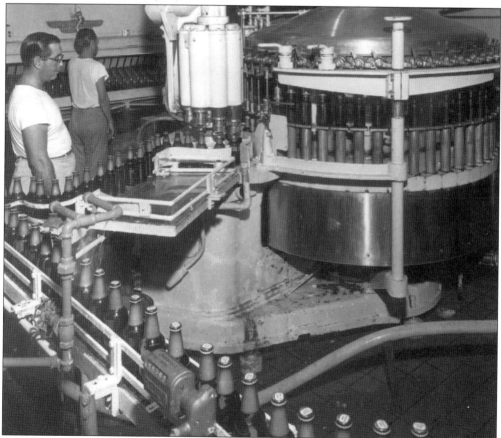

Employees of the Southern Brewing Company work near a beer bottling machine in this c. 1955 photograph. (Courtesy of HCPL.)

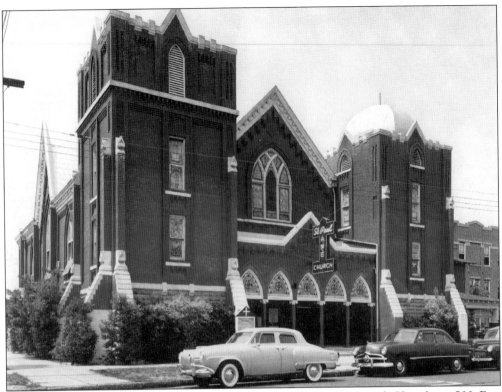

In this May 21, 1951 image is St. Paul African Methodist Episcopal Church at 500 East Harrison Street. (Courtesy of HCPL.)

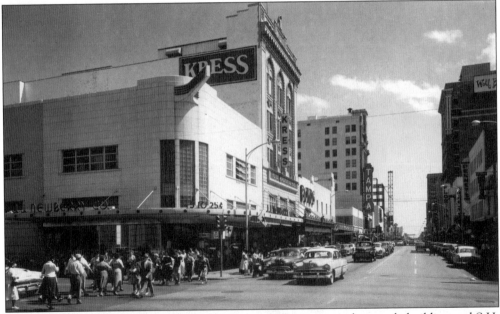

This photograph provides a view of J.J. Newberry & Co. in its art deco–style building and S.H. Kress & Company on the 800 block of North Franklin Street. The picture was taken from the Cass Street intersection on March 30, 1956. (Courtesy of HCPL.)

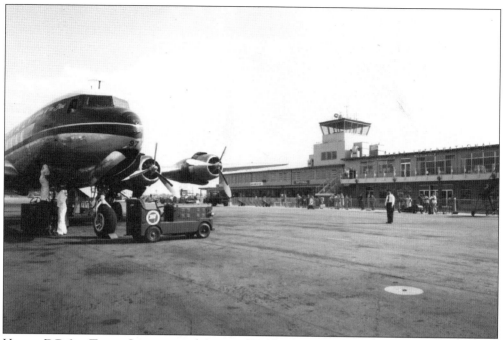

Here, a DC-6 at Tampa International Airport (TIA) is serviced on the tarmac. TIA was built a few years after World War II, and this terminal was replaced by the new jet-age Tampa International Airport a few years after it was built. (Courtesy of HCPL.)

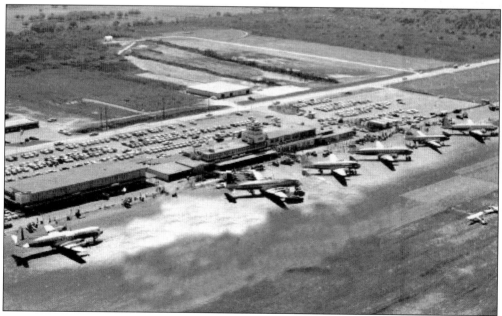

In this aerial view of Tampa International Airport taken on March 4, 1959, planes are visible along the tarmac, awaiting permission to take off.

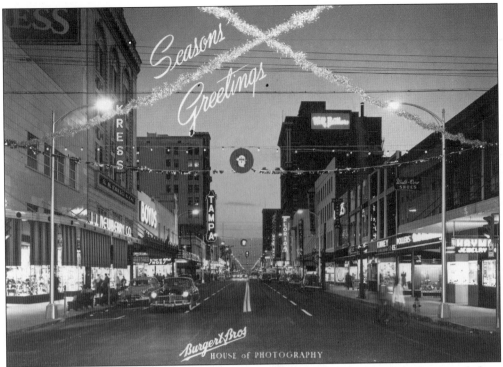

Christmas decorations on Franklin Street light up this December 1950 view looking south from Cass Street. (Courtesy of HCPL.)

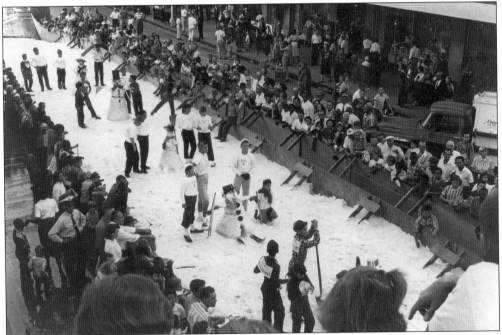

A "snow show" on Franklin Street was held as a Christmas promotion in November 1958. The fake snow is often the most that Floridians have the opportunity to see. (Courtesy of HCPL.)

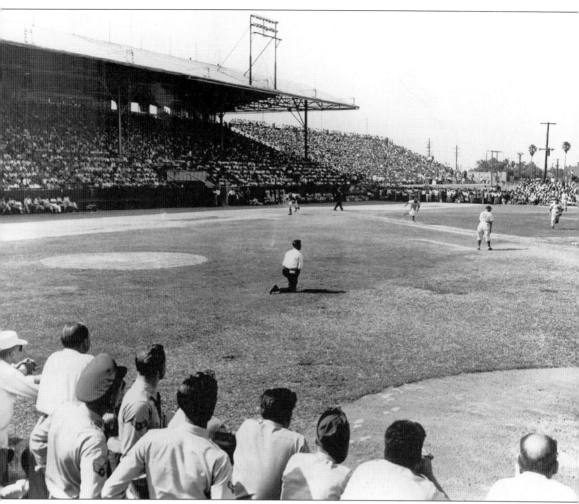

The Dodgers and Chicago White Sox play baseball at Plant Field on March 28, 1954 in front of cheering crowds. (Courtesy of HCPL.)

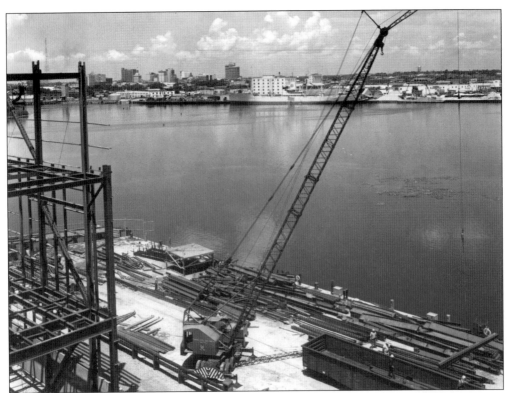

The port area, including the Tampa Electric Complex with a crane and steel girds at Hookers Point, is pictured here in July 1954. (Courtesy of HCPL.)

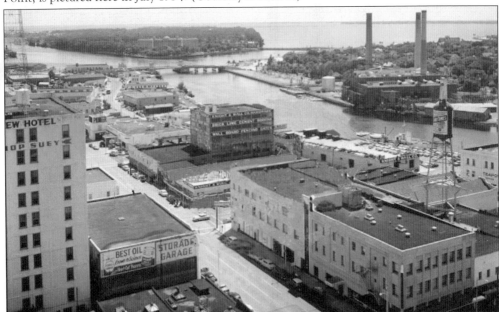

This was the view on September 17, 1954 of Tampa's downtown district along the 100 to 300 blocks of Tampa Street, which runs parallel to the Hillsborough River. Davis Island is visible across the canal, and to the right is the Tampa Electric Company's Hyde Park Power Plant.

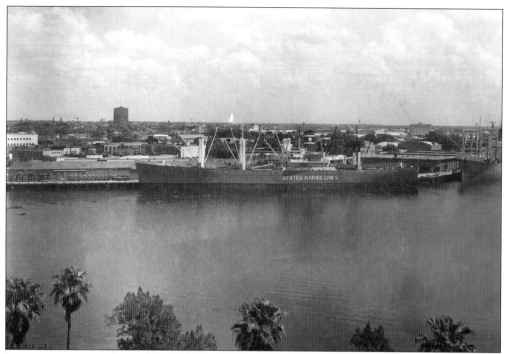

In the photograph above, ships are docked at the Luckenbach Gulf Steamship Company docks on April 12, 1954. (Courtesy of HCPL.)

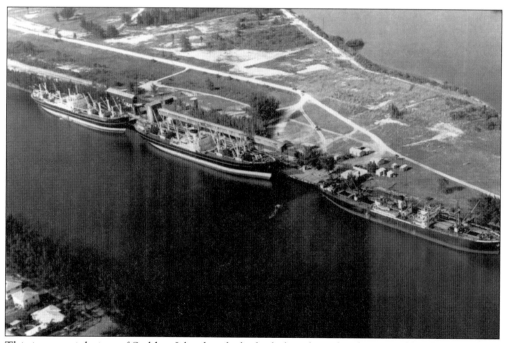

This is an aerial view of Seddon Island with docked phosphate freighters visible; this scene was captured on April 29, 1955. (Courtesy of HCPL.)

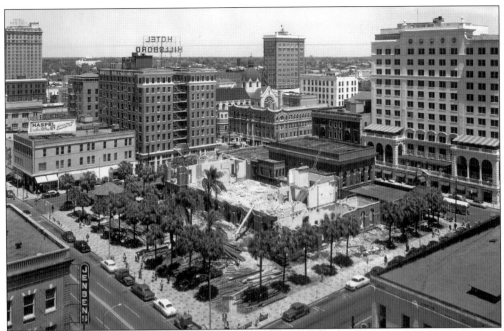

The Hillsborough County Courthouse is pictured here while in the process of being demolished on April 29, 1953. (Courtesy of HCPL.)

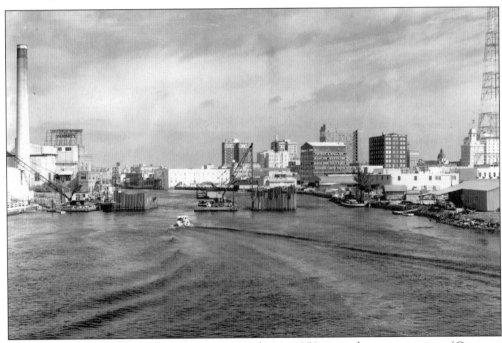

The Brorein Street Bridge, seen here on March 14, 1958, is under construction. (Courtesy of HCPL.)

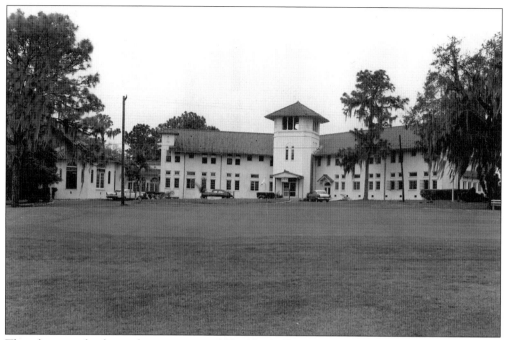

The photograph above shows a view of Florida College across its well-trimmed grounds on February 25, 1959. (Courtesy of HCPL.)

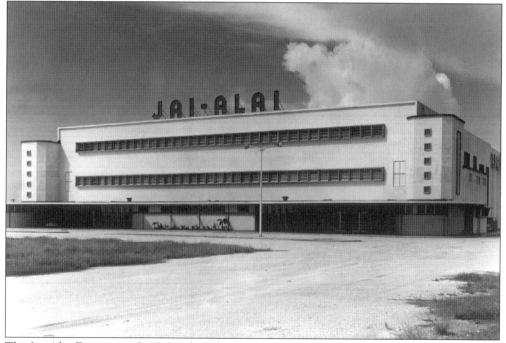

The Jai-Alai Fronton at 5125 South Dale Mabry Highway is seen in this September 27, 1954 photograph. The building was demolished a few years ago and a Home Depot store now stands in its place. (Courtesy of HCPL.)

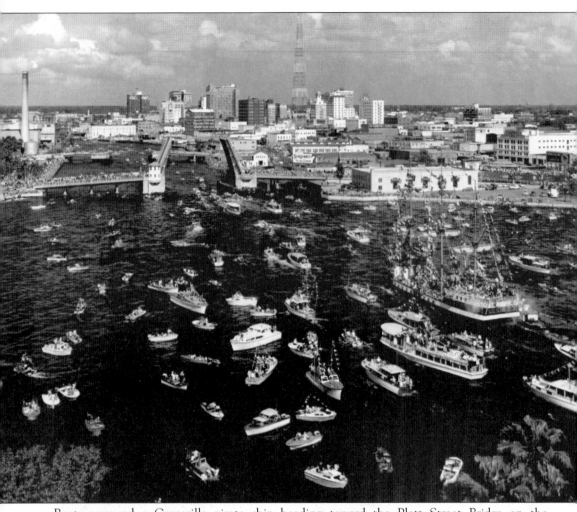

Boats surround a Gasparilla pirate ship heading toward the Platt Street Bridge on the Hillsborough River in this 1959 photograph. (Courtesy of HCPL.)

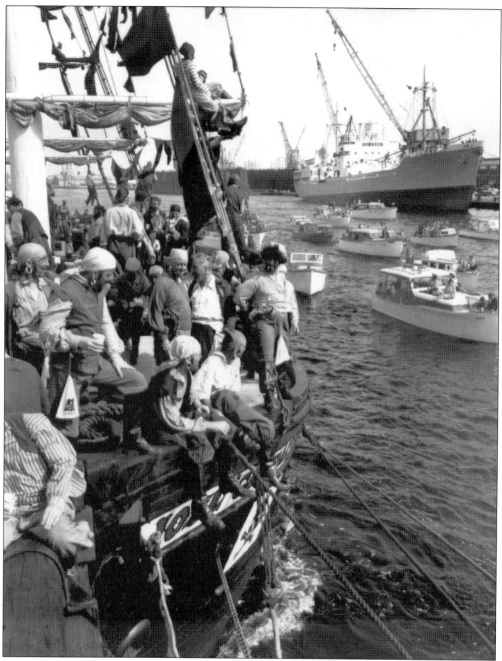

"Pirates" aboard a ship during the Gasparilla invasion in 1954 are the subject of this fascinating photograph. (Courtesy of HCPL.)

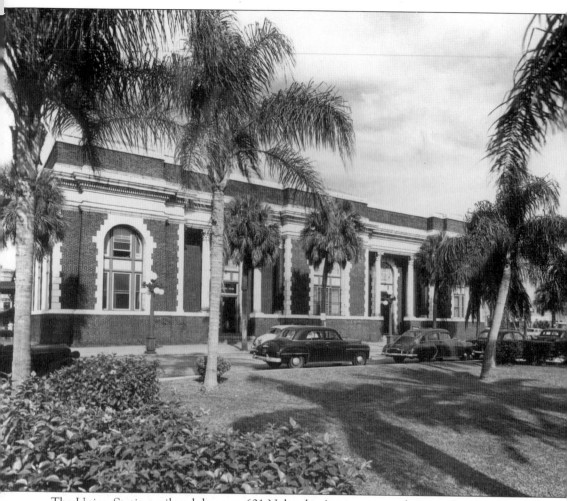

The Union Station railroad depot at 601 Nebraska Avenue is seen here on October 15, 1952. Tampa Union Station, which first opened on May 15, 1912, was built at a cost of $250,000 by three railroads—the Atlantic Coast Line, the Seaboard Air Line, and the Tampa Northern. This 13,401-square-foot, red brick structure operated for 72 years as Tampa's main passenger terminal, bringing new settlers to the area and transporting soldiers during two World Wars. Ornate balconies, vaulted ceilings, terrazzo floors, and skylights were among the features of the beautifully decorated interior. As the United States entered World War II, the skylights were painted black for security reasons. By 1984, the station was in such disrepair that it was boarded up and officially closed. A restoration project began in June 1997 and $2.6 million later, Tampa Union Station reopened on May 7, 1998 with funding from the Florida Department of Transportation, the Florida Division of Historical Resources, the Department of State, the National Trust for Historic Preservation, and the county and city. The story of Tampa Union Station exemplifies the great pride the residents of Tampa have for the history of their beautiful city. (Courtesy of HCPL.)